ideals®
CHRISTMAS

75TH ANNIVERSARY EDITION

*A special commemorative collection,
including new and classic selections*

*As the name implies—a book of old-fashioned
Christmas ideals, homey philosophy, poetry, music, inspiration, and art.*

—DESCRIPTION FROM THE FIRST ISSUE OF IDEALS, PUBLISHED IN 1944

NASHVILLE, TENNESSEE

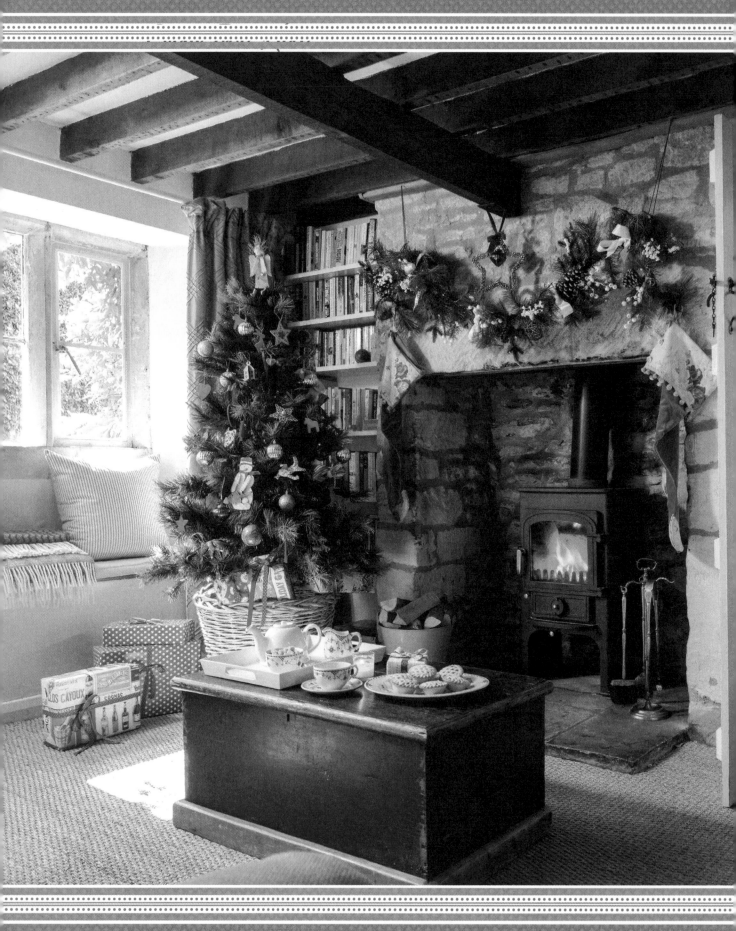

Christmas Joy
Elisabeth Weaver Winstead

Silver snow on the window,
green wreath on the door;
the Christmas tree glitters
from ceiling to floor.

Soft candlelight flickers;
the blazing fire glows;
stockings flank the mantel;
presents wear red bows.

Early Christmas morning,
our gifts of love we bring
to celebrate the birthday
of Jesus Christ, our King.

Sweet voices join in carols—
family chorus, precious parts—
singing glory to our God,
as that bright star lights
 our hearts.

Image © Colin Poole/GAP Photos

It's Christmastime
Author Unknown

When sleigh bells jingle
 in the lane
and warm-clad carolers make
 their rounds,
open your door to Christmas,
welcome its happy sounds.

When Yule logs blaze upon
 the hearth
and kitchens scent the air
 with spice
and holly hangs on your
 festive door,
Christmas smells so nice.

Outside your door is a
 Christmas wreath,
and bright lights twinkle on
 every tree.
People are smiling and pleasant;
Christmas is lovely to see.

As you open your door
 this Christmas
to its color, its goodness, its tone,
may Christmas come
 into your heart
as you make it your very own.

Christmas
Eileen Spinelli

At Christmas there are lovely things to see—
behold, a burst of colors on the tree,
and cozy rooms awash with candlelight,
and stars that stitch bright patterns in the night;
ribbons, wrappings done in reds and greens,
and through the window, winter snowfall scenes.

At Christmas there are pleasing things to smell—
roasted chestnuts corner vendors sell,
ginger cookies cooling on a tray,
a jar of spice, a pungent pine bouquet,
and when the oven door is opened wide,
a tempting whiff of turkey from inside.

At Christmas there are splendid things to touch—
warm and fuzzy coats and hats and such,
velvet vests and hand-knit slipper socks,

a gift that jiggles when you shake the box,
a hand, a snowflake delicate and frail,
a chunk of ice, a merry batch of mail.

At Christmas there are luscious things to taste—
a fruited stollen filled with almond paste,
a mug of cocoa or a glass of punch,
a minty candy cane for after lunch,
a juicy orange or a mellow pear,
perhaps plum pudding, elegant and rare.

At Christmas there are joyful things to hear—
the sound of church bells ringing deep and clear,
the festive singing voices of a choir,
a snap of twigs, the crackling of a fire,
the story told at bedtime o'er and o'er
of peace on earth, goodwill forevermore.

Silhouette
June Masters Bacher

A silhouette of Christmastime
reflects upon the snow,
crisscrossing shadows merrily
as shoppers come and go.
They skate across the silver sheen
made by the fragile ice,
dart in and out of evergreen
that fills the air with spice.
They meet and greet on every street;
then silently they part,
bulging with packages that show
each shadow has a heart.

It Must Be Christmas
Jewell Johnson

Footsteps crunch on snow-packed
 pathways;
coins jingle as they drop in red kettles;
childish voices lisp, "Away in a Manger."
It sounds like Christmas.

Marshmallows float in cups of hot cocoa;
pine tree fragrance fills every room;
whiffs of cinnamon waft from the kitchen.
It smells like Christmas.

Mailboxes overflow with cheery greetings;
brightly wrapped presents crowd the tree;
excitement shines in each child's eyes.
It looks like Christmas.

Strife is forgotten;
peace overflows;
joy stirs our hearts.
It feels a lot like Christmas.

Image © Victor McLindon/Advocate Art

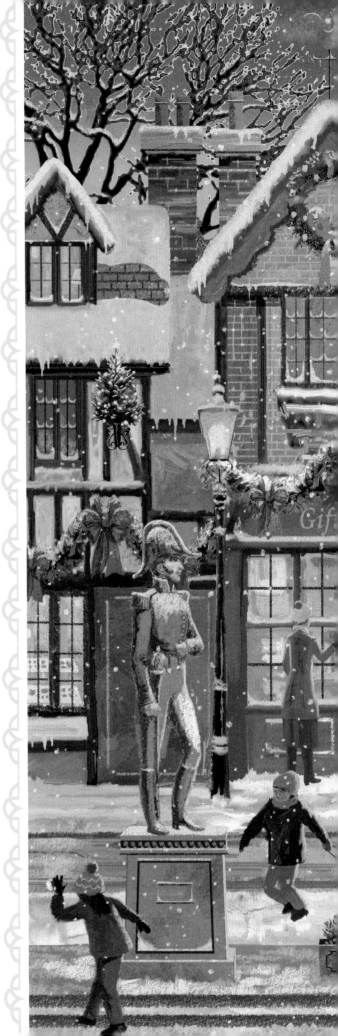

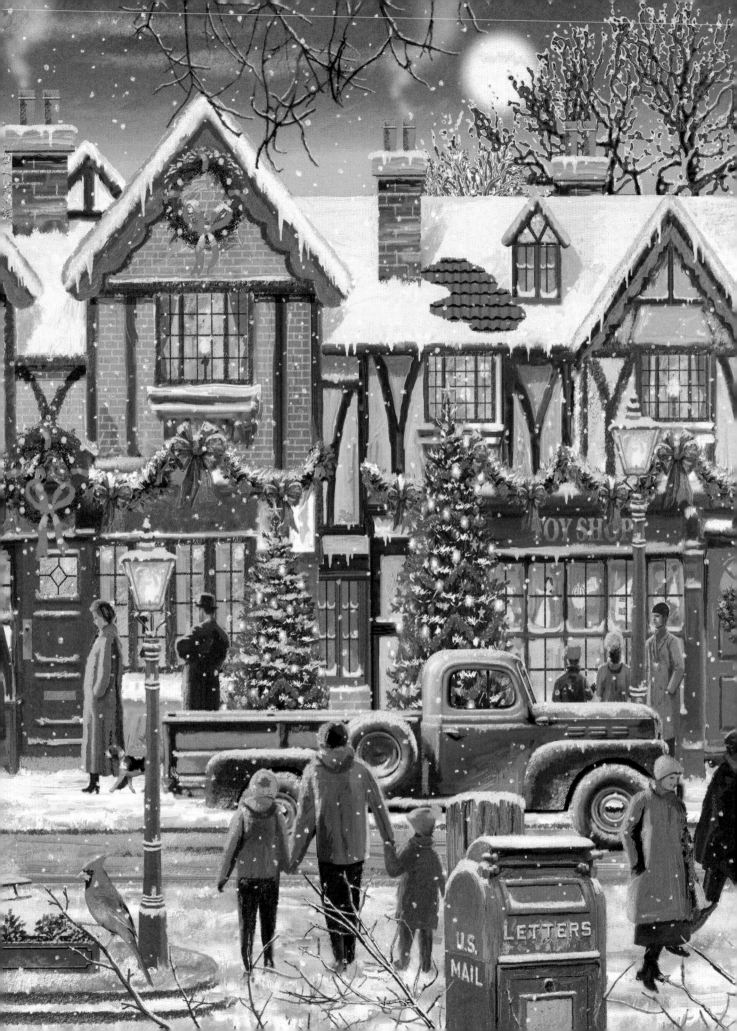

Waiting

Joan Donaldson

For many years, my mother would hang an Advent calendar on December 1 in hopes of placating the youthful impatience of my brother and me. We longed to dash through the days before Christmas and leap to the morning when we could open our presents. The cheerful Advent calendar offered something to look forward to each day in the meantime, and a contrast to the gloomy early December days, when the temperatures and waning light limited after-school outdoor play.

Like most children, my brother and I longed to know what gifts our parents planned to give us. Since we knew better than to look beneath our parents' bed where they stored our presents, my brother and I instead looked forward to the moment after supper when one of us would open the little flap marked for that date and enjoy the hidden surprise. A joyful Christmas scene illustrated the front of each year's rectangular Advent calendar. But the particular scene varied, from a Nativity or a Christmas tree or perhaps a village where Christmas carolers strolled. Each day thoughts of what might lie underneath the flap percolated in my mind as I walked home from school. Would the image be of a star or lamb or some other small symbol that nudged our hearts to remember the true meaning of Christ's birth? When we folded back the little flap and spied the tiny image underneath, we knew we were one day closer to our family's Christmas celebration.

As my brother and I grew into our middle school and high school years, the tradition of an Advent calendar lost its charm and fell away as we filled the days before Christmas with activities like caroling with our church youth group, attending holiday events at school, and gift shopping with our friends.

The passing years have taught me that waiting is a gift. Advent allows me time to reflect upon how God had prepared for Emmanuel's coming, and to renew my sense of wonder in the miracle of Christ's birth.

But when my husband and I adopted our two young sons, I bought an Advent calendar for our new family. I hoped to provide encouragement as they struggled, like I had, through the weeks of anticipation leading to Christmas. The artwork depicted a snowy New England village, surrounded by a border that told an additional story of woodland creatures celebrating Christmas. Now I was the parent introducing a tradition to my children.

This year, I look forward to giving my two-year-old grandson his first Advent calendar. As his family travels through the moments preceding Christmas, and his wee fingers open the small doors, I hope the illustrations delight him. And as he matures, may he also discover the blessing of waiting for the joy of Christmas.

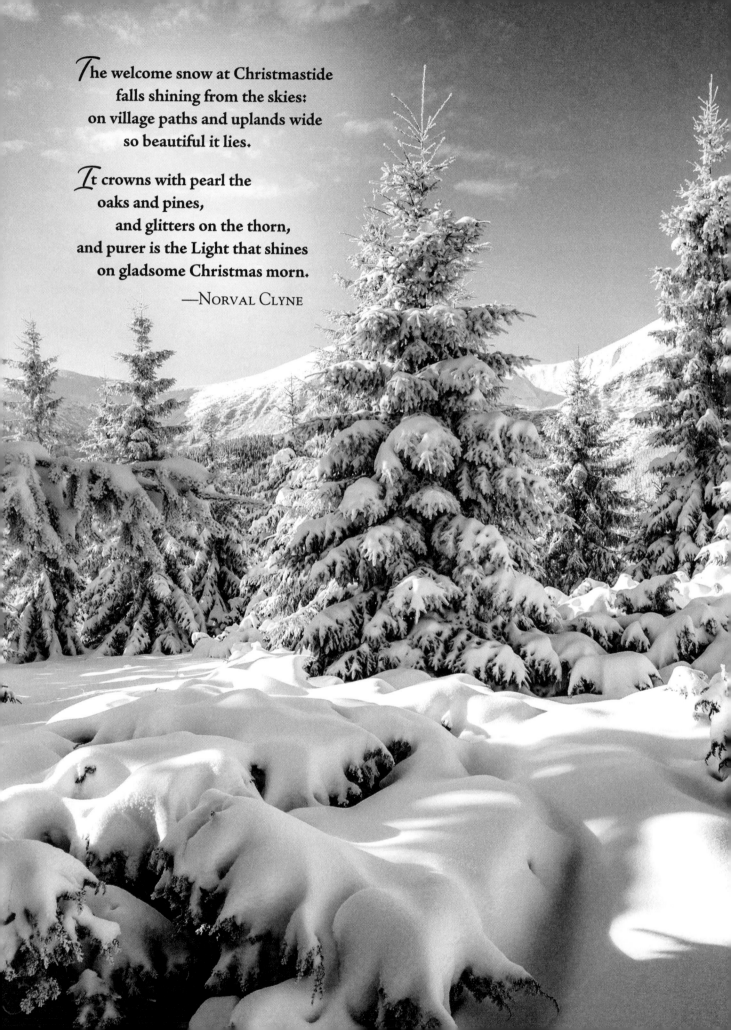

The welcome snow at Christmastide
falls shining from the skies:
on village paths and uplands wide
so beautiful it lies.

It crowns with pearl the
oaks and pines,
and glitters on the thorn,
and purer is the Light that shines
on gladsome Christmas morn.

—NORVAL CLYNE

Snowflakes
Mary Stoner Wine

A million little snowflakes
came tumbling through the air
and covered winter's
　　bleakness
with beauty everywhere.

The rosebush bowed with
　　whiteness,
as though its work were done
and all the thorns were
　　diamonds
that sparkled in the sun.

The tall, soot-blackened
　　chimneys
stood in a ghostly row,
and merry-hearted children
made angels in the snow.

Then moonlight glowed
　　in softness
above a world of white;
the twinkling stars,
　　resplendent,
caught up the sparkling light.

Wonderful Wintertime
Nora M. Bozeman

Beneath a sky of cobalt blue,
the day is wrapped in winter's hue.
Diamond-sparkled snowflakes fly,
like frost-kissed magic from on high.

Vivid blue jays, brave and bold,
hop around and loudly scold.
Cardinals decorate the scene,
on snowy boughs of evergreen.

Icy winds sculpt drifts of white
and etch each silver-frosted night.
December hangs her frozen head
and sleeps upon an ermine bed.

Majestic white spruces at Carpathian National Park, Ukraine.
Image © Creative Travel Projects/Shutterstock

Christmas Brunch
Betty Wallace Scott

Festive damask on the ground,
windswept firs for classic sound,
elegance in ice hung high
to chandelier the winter sky.
Red-coated guests arrive to dine
on berries from a circling vine.

Chickadees
Minnie Klemme

Cheerful little chickadees,
how do you stand the cold?
Ice and snow are all about;
we're deep in winter's hold.

But God has fashioned you with care,
made for you a muff—
feathers soft to keep you warm—
and it is enough.

Red Birds
Johnielu Barber Bradford

Four red birds hide
from sifting snow
near my front door
where cedars grow.
Four scarlet flames
defy my gloom,

for soon I see
my cedars bloom!
No lovelier sight,
when red birds hide,
except those specs
close by their side—

four dull, drab bits
of snuggling down
against red coats,
four mates in brown.

HOLIDAY GREETINGS *by Abraham Hunter.*
Image © Abraham Hunter/
MHS Licensing

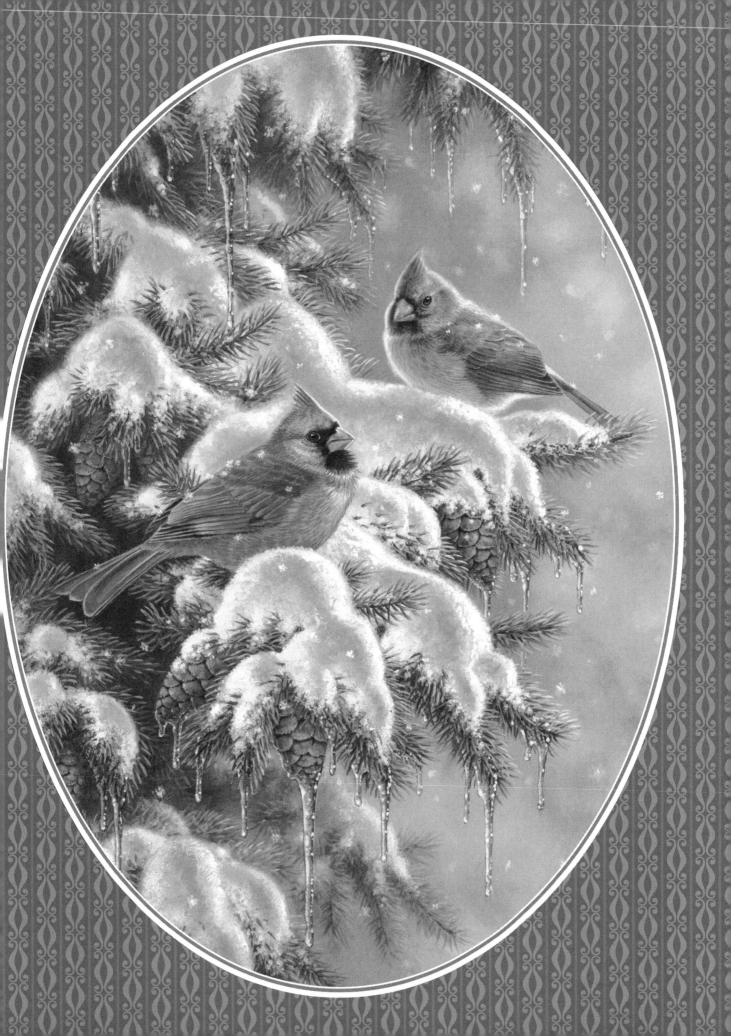

Christmas Thoughts for All the Year

Editors of *McCall's*

*C*hristmas is celebration, and celebration is instinct in the heart. With gift and feast, with scarlet ribbon and fresh green bough, with merriment and the sound of music we commend the day.

Christmas is a celebration, but the traditions that cluster sweetly around the day have significance only if they translate the heart's intention—the yearning of the human spirit to compass and express faith and hope and love. Without this intention, the gift is bare, the celebration a touch of tinsel, and the time without meaning. As these attributes, exemplifying the divine spark in mankind, informed the first Christmas and have survived the onslaughts of relentless time, so do they shine untarnished in the present year of our Lord.

Faith and hope and love, which cannot be bought or sold or bartered but only given away, are the wellsprings of Christmas celebration. These are the gifts without price, the ornaments incapable of imitation, discovered only within oneself and therefore unique. They are not always easy to come by; but they are in unlimited supply, ever in the province of all.

This Christmas, mend a quarrel. Seek out a forgotten friend. Dismiss suspicion, and replace it with trust. Write a love letter. Share some treasure. Give a soft answer. Encourage youth. Manifest your loyalty in word and deed. Keep a promise. Find the time. Forego a grudge. Forgive an enemy. Listen. Apologize if you were wrong. Try to understand. Flout envy. Examine your demands on others. Think first of someone else. Appreciate. Be kind; be gentle. Laugh a little. Laugh a little more. Deserve confidence. Take up arms against malice. Decry complacency. Express your gratitude. Go to church. Welcome a stranger. Gladden the heart of a child. Take pleasure in the beauty and wonder of the earth. Speak your love. Speak it again. Speak it still once again.

These are but inklings of a vast category; a mere scratching of the surface. They are simple things—you have heard them all before—but their influence has never been measured.

Christmas is celebration, and there is no celebration that compares with the realization of its true meaning—with the sudden stirring of the heart that has extended itself toward the core of life. Then, only then, is it possible to grasp the significance of that first Christmas—to savor in the inward ear the wild, sweet music of the angel choir; to envision the star-struck sky, and glimpse, behind the eyelids, the ray of light that fell athwart a darkened path and changed the world.

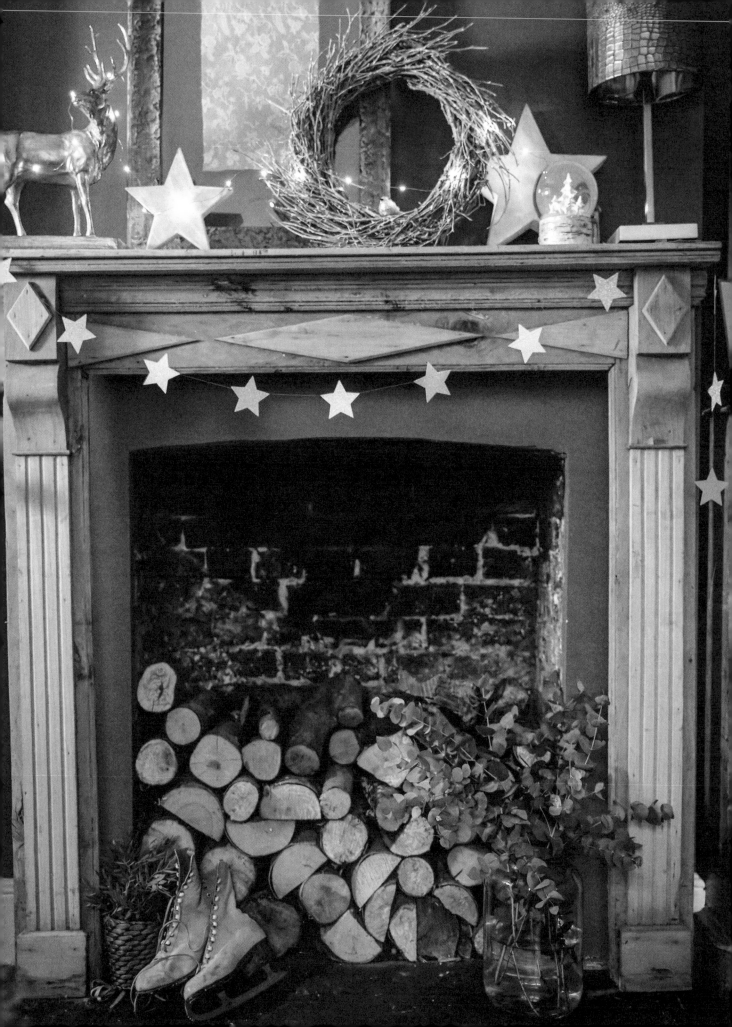

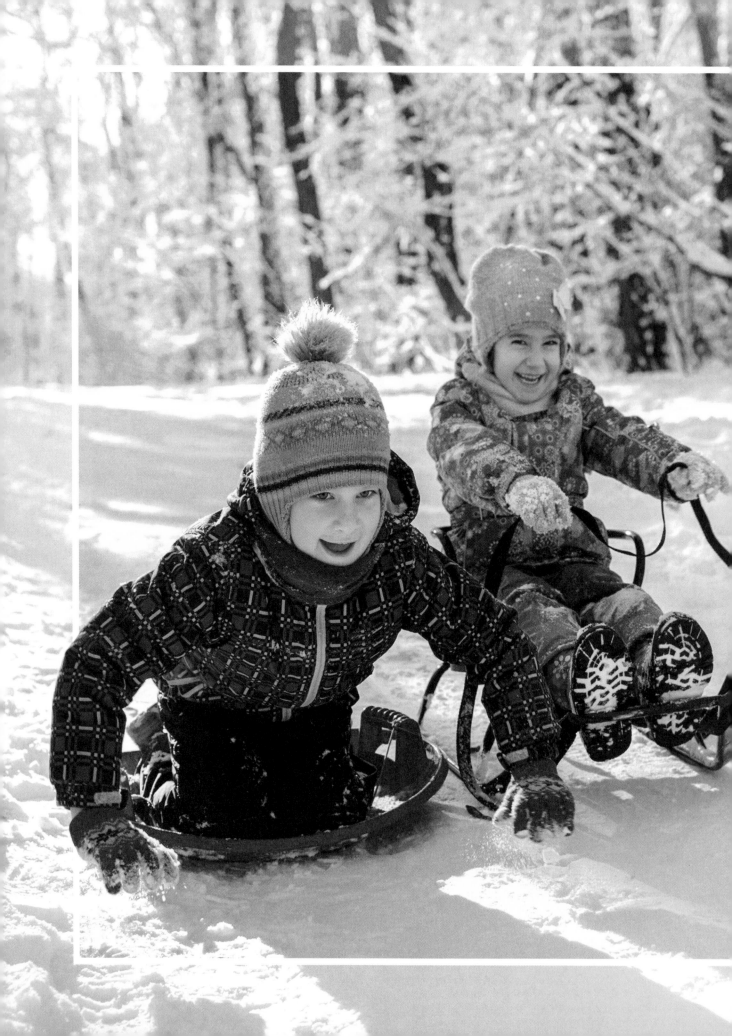

Christmas Sled
Author Unknown

Oh, for the winters that used to be!
The winters that only a child may see!
Rich with the snowflakes' rush and swirl,
keen as a diamond, pure as a pearl,
brimming with healthful, rollicking fun,
sweet with their rest when the play was done,
with kindly revels each day decreed,
and a Christmas sled for the royal steed.

Down from the crest with shrill hurray!
Clear the track, there! Out of the way!
Scarcely touching the path beneath,
scarce admitting of breath to breathe,
dashing along, with leap and swerve,
over the crossing, round the curve.
Talk of your flying machines! Instead,
give me the swoop of that Christmas sled.

Children's Winter
Marion Doyle

Silver skates on silver ice
flash back and forth,
 whirl and slice,
beneath a silver sky;
while clearly, like a silvery bell,
happy shouts and laughter tell
every passerby
how wonderful it is to glide
with giant's sweeping
 league-long stride,
flinging silver spray;
how wonderful it is to look
like rainbow-birds upon
 the brook
on such a silver day.

Image © Elina-Lava/Shutterstock

The New Skates

Clara Brummert

When the autumn breeze gives way to crisp winter air, I feel my childhood memories begin to stir. As the first snow sifts down, the years unfurl like holiday ribbon, taking me back to a day blanketed in deep drifts and filled with even deeper love.

That year, winter arrived early. By the time school let out for Christmas vacation, the neighborhood hedges looked like mounds of powdered sugar, and the pond at the edge of town had turned into thick, frozen glass.

One afternoon, my best friend came over and we helped Momma roll cookies and then decorate the bell shapes with icing and sprinkles. As we nibbled cookies and stirred cocoa with candy canes, we saw kids gather outside with their skates and head to the pond.

My friend and I were allowed to tag along. Feeling far older than our tender eight years, we jauntily kicked through the snow, dangling our skates by the laces. Hers was a ragged pair of black hockey skates outgrown by her brother, and mine were a scuffed pair with dull blades that I'd borrowed from a cousin.

We laced up our skates and ventured onto the ice. We were both really good skaters, but my dull blades gave her an edge and I fought to catch up as she nimbly glided ahead. I giggled and panted as we circled the pond, practiced our spins, and anxiously awaited the races.

The high school boys sped in and out of the crowd, teasing the older girls by nabbing their stocking caps. Carols played on a radio, and a cluster of girls sang along. And then, above the cheerful din, someone yelled, "Let's race!"

The little girls were called to the line first and we took off in a flurry of flapping arms and clicking skates. My sides heaved and I thought I would win, but then my friend's blades crossed the line an instant before mine. As the winner she was allowed to race with the next group of girls. It took only a moment for me to find my smile, and I waved encouragement as she stepped up to the line.

At the whistle the girls took off and, one by one, my friend passed them all until she was just behind the leader. I chewed on a mitten when she moved ahead by a hair.

We all gasped when, suddenly, she went down hard. She'd tripped on a frayed lace when a hook pulled loose from her tattered skate. She bounded up but crossed the line last. She limped home, and I carried her skates.

During Christmas service at church the next morning, my thoughts stole back to the elegant pair of white skates that had been under the tree. I'd run my finger over the shiny blades and hoped

that my friend had received a pair too. But later that day when we met outside, she still clutched her old skates. She gallantly patted my back when she spied my new pair, and then with a look of determination set off for the pond.

I felt like lightning in my new skates. I zipped forward for a while, practicing for the races, and then swept over to where my friend was still fiddling with her laces. I stared when she held up another hook that had pulled loose from her skate. Just then someone yelled for us little girls to get ready for the first race.

I glanced at the girls lining up on the ice and then turned back to my friend, who sat with her chin in her hands. I quickly unlaced my skates and urged, "Wear these." Her soft eyes held mine for a moment, and then she deftly pulled on my skates.

She easily won the first race and then lined up with the next group. My white skates were a blur as she pulled ahead, and she threw up her arms when she crossed the line first.

Later, hand in hand, we tromped home through the drifts.

From her top porch step my best friend turned and waved. I waved back, and we grinned at each other as the Christmas lights glowed all around us.

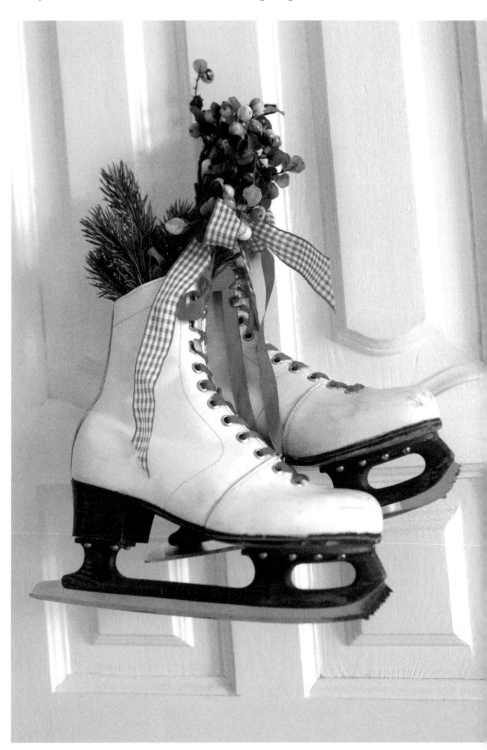

Image © Kristina Bessolova/Shutterstock

Christmas Ornaments

Rebecca Barlow Jordan

Decorating our Christmas tree is a ritual my family has enjoyed for decades. Nothing brings a bigger smile to my face than simple, old-fashioned ornaments—or those we purchased that hold special meaning—hanging on less-than-perfect, spindly trees.

As a young mom, I joined a group of friends selling at craft sales to earn extra income for Christmas. Among my handmade items were Christmas ornaments. I chose familiar and cheaper materials to fit our budget: walnut shells, cotton balls, felt squares, polyester and cotton scraps, and old buttons and beads. From these, I created mice with whiskers; Amish women, faceless with calico bonnets and skirts; small candy canes; fabric wreaths; and stuffed pepper-

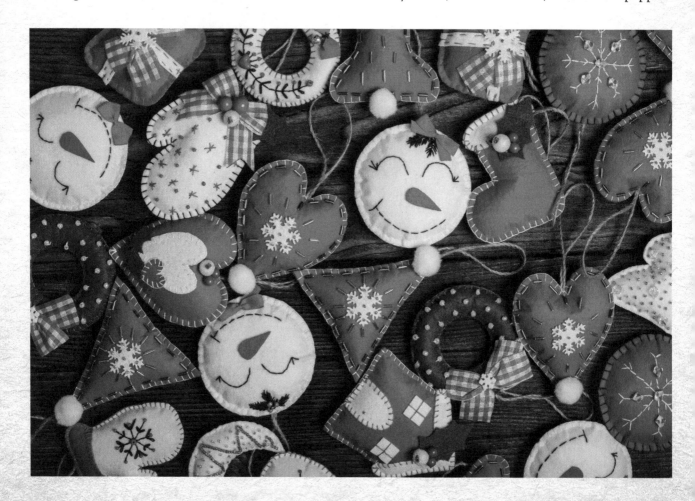

mint sticks. And yes, I even included Styrofoam ball-shaped ornaments, ubiquitous in those days. My favorite to create were egg ornaments, and my artistic drive pushed me long past midnight some days as I worked on them. Draining each egg and carefully halving some, I selected meaningful miniatures, scraps of velveteen, and shiny rickrack or ribbons to create each piece. Some held the symbols of Christmas: tiny Baby Jesus in a manger, the three kings, or a shining star. I spent hours on each ornament, as if they were my Sistine Chapel. In the end, few sold, so guess where they landed? On my own tree.

Through the years, the tree limbs sagged as we added more ornaments, each one with a special significance. One year our daughter surprised us with ornament gifts that reminded her not only of a particular character trait she saw in each family member, but also one she associated with Christmas itself. She presented me with a ceramic lamb, representing one of the sweet animals at the Nativity, but also because she saw a lamb's gentle quality in me. Her father received a gold metal star, a picture not only of the wisdom she identified in her dad, but also a reminder of the Star that led the shepherds and Wise Men to Jesus.

As the house emptied, and the children married and moved away, I added new colorful ball ornaments to our Christmas tree to replace many of the old decorations that had broken or faded with age. One Christmas, our eldest daughter presented us with a hand-decorated ornament to deliver a delightful message—the expected arrival date of her next child—our granddaughter!

Once the grandchildren began visiting us, I decided to try a new approach, one that would appeal to their young ages. Instead of traditional ornaments, I pulled all the stuffed Beanie bears from my collection (left over from overzealous "investment" Beanie Baby purchases) and covered a smaller tree. The kids loved it, and so did I—so much that the bears have made their annual residence there each Christmas.

Those ornaments have become a sweet reminder, as the grandkids have grown older. As I place each bear on the tree limbs every December, I remember to celebrate the wonder of Christmas again as if seen through a child's eyes. And that stirs up even more precious memories of our own children and their early Christmas celebrations.

Whether our decorations were handcrafted, breakable balls, or smiling bears scattered on our trees every Christmas, the memories of those ornaments never fail to fill me with a joyful celebration of family and of the precious years we've shared together. Every ornament has a story to tell, but each one is a story of love.

little tree

E. E. Cummings

little tree
little silent Christmas tree
you are so little
you are more like a flower

who found you in the green forest
and were you very sorry to come away?
see i will comfort you
because you smell so sweetly

i will kiss your cool bark
and hug you safe and tight
just as your mother would,
only don't be afraid

look the spangles
that sleep all the year in a dark box

dreaming of being taken out and allowed to shine,
the balls the chains red and gold the fluffy threads,

put up your little arms
and i'll give them all to you to hold
every finger shall have its ring
and there won't be a single place dark or unhappy

then when you're quite dressed
you'll stand in the window for everyone to see
and how they'll stare!
oh but you'll be very proud

and my little sister and i will take hands
and looking up at our beautiful tree
we'll dance and sing
"Noel Noel"

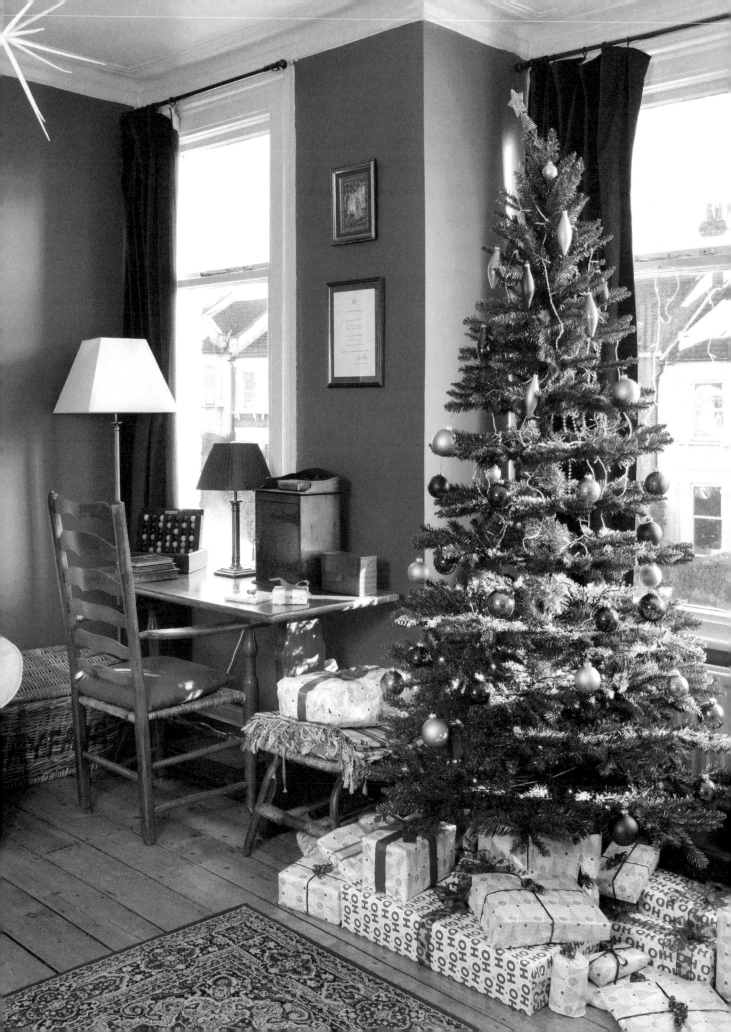

Christmas, USA

Doris A. Paul

*C*hristmas is Christmas whether one lives in a hamlet or a metropolis. The well-worn banner hanging high above the street in the one business block of the village proclaiming "Merry Christmas and a Happy New Year" is as meaningful to those who see it as is the luxuriant mass of Christmas color and lights to the person in the city.

My mind at this time of year is crowded with thoughts of both—the simple decorations and festivities in my hometown in Indiana when I was a child, and the fairyland of New York City which I visited on fifteen successive years at the holiday season during my adult years.

One highlight of my trip to the city was always attendance at one of the annual performances of Tchaikovsky's *Nutcracker Suite* presented by the New York City Ballet. The theater at matinee time was always crowded with children. The tenor of their excited voices before the performance and at intermission, and their delighted laughter during the spectacular show was always worth the price of admission. So well acquainted with the work were some of the children that they hummed snatches of "Waltz of the Flowers" and other tunes in the ballet while waiting.

The traditional Christmas show at Radio City Music Hall never failed to move me to tears: the angel in the sky singing "Oh, Holy Night!"; the brilliant star leading the Wise Men and shepherds to the manger; the dear (live) animals—burros, sheep, the white steed carrying a gold-clad potentate, and the stoic camel plodding his way across the softly lighted stage.

Walking down Fifth Avenue and in the immediate area was always an adventure. One year I jotted down the sights that impressed me most: a great topaz mounted in a gold star, its multiple rays shining on the "snow" in Tiffany's window; old men vending roasted chestnuts and hot pretzels from their little carts; a Salvation Army band of six playing familiar carols; store windows decorated with orderly Jack Frost designs through which one could see glassy ships laden with treasures to touch the feminine heart; a little man playing a violin in front of Carnegie Hall; replicas of huge organ pipes and carolers on the facade of Saks Fifth Avenue store, their music spilling out over the crowded streets; a lone suppliant kneeling in an attitude of deep prayer in St. Patrick's Cathedral; animated figures made of a substance like sugar candy moving in a pastel fairyland in Lord & Taylor's windows, attracting large crowds retained behind an iron railing; and *The Tree* at Radio City. That year it glittered with coppery discs above the skaters in their bright cos-

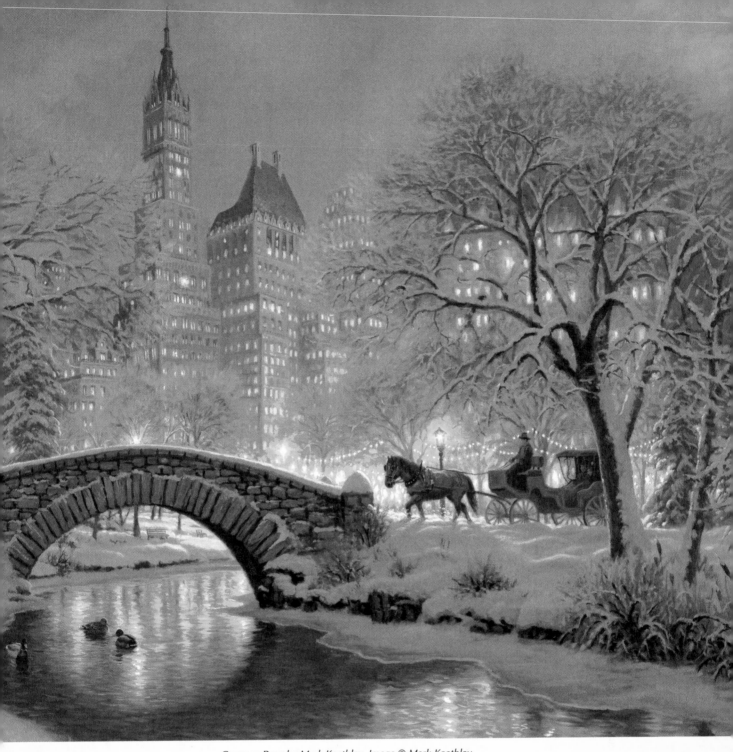

CARRIAGE PARK *by Mark Keathley. Image © Mark Keathley*

tumes. One man with a snowy thatch moved with the lithe grace of a young lad. The mall leading to the tree and ice arena from Fifth Avenue was lined with "snowmen" made of white wire.

When night descended, the city was a-sparkle with lights. Year after year one tall building flashed great clusters of red lights reminiscent of giant poinsettias.

Thinking about the magnificence of New York City at Christmas, I am reminded of a poignant story gleaned from a newspaper. A small boy clutching the hand of his father as the two walked down a New York avenue one night, amid the fantastic Christmas displays, suddenly stopped. Pointing skyward, be exclaimed excitedly to his father: "Look! Look! A star!"

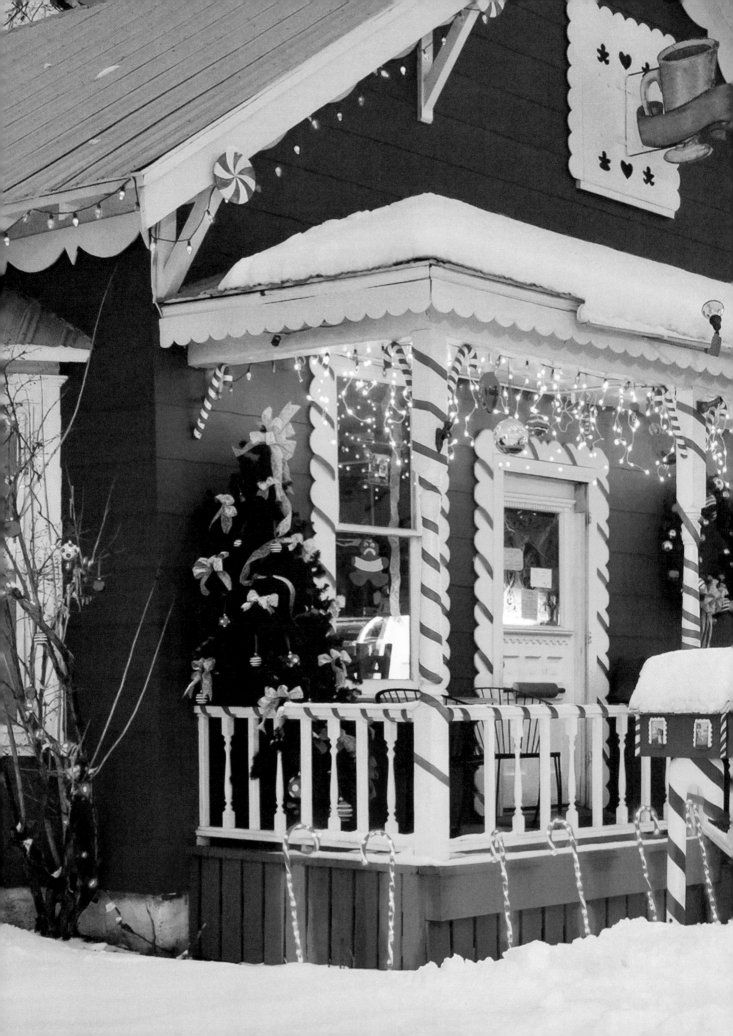

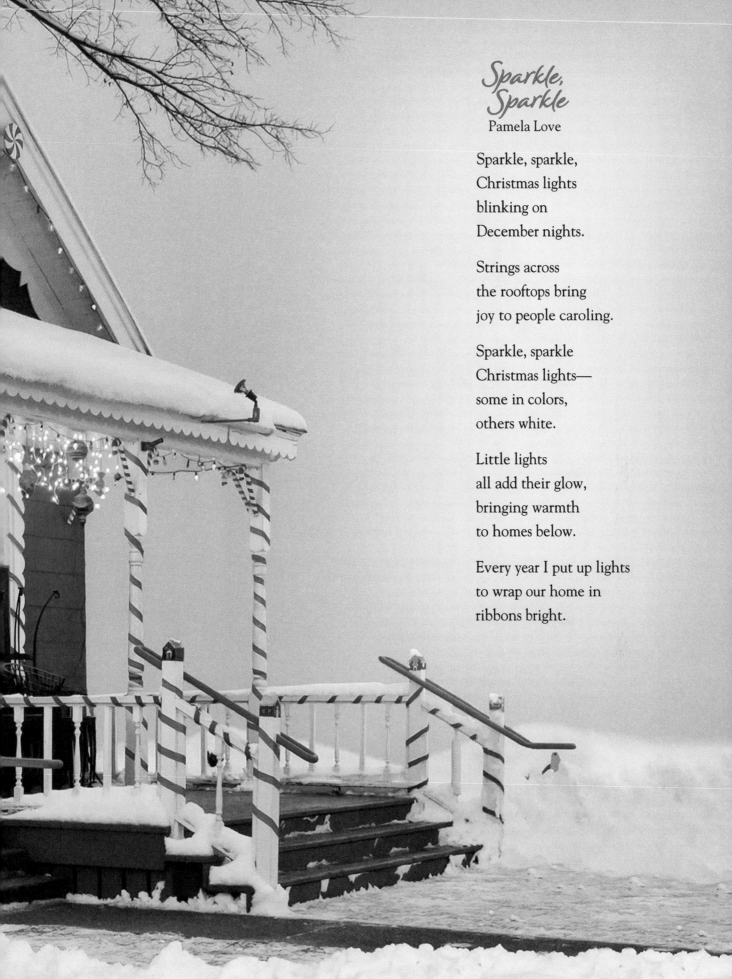

Sparkle, Sparkle
Pamela Love

Sparkle, sparkle,
Christmas lights
blinking on
December nights.

Strings across
the rooftops bring
joy to people caroling.

Sparkle, sparkle
Christmas lights—
some in colors,
others white.

Little lights
all add their glow,
bringing warmth
to homes below.

Every year I put up lights
to wrap our home in
ribbons bright.

Image © karamysh/Shutterstock

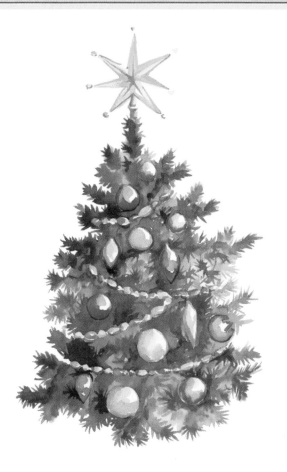

While Stars of Christmas Shine
Emilie Poulsson

While stars of Christmas shine,
lighting the skies,
let only loving looks
beam from our eyes.

While bells of Christmas ring,
joyous and clear,
speak only happy words,
all love and cheer.

Give only loving gifts,
and in love take;
gladden the poor and sad
for love's dear sake.

The Christmas Light
John C. Bonser

I love the sight of Christmas lights
this season of the year,
the merry sounds that now abound
in melodies of cheer.

I love the words that can be heard
in carols that are sung,
the happy cries and sparkling eyes
among the very young.

I love the scenes of evergreens
and wreaths hung everywhere,
soft-falling snow and candle glow
and people bowed in prayer.

I love the bells whose glad notes swell
in tones of purest gold,
how goodness still our lives will fill
as God's great plan unfolds.

I love the light, that special night,
the shepherds saw afar
and ran to find, for humankind,
His bright and morning star!

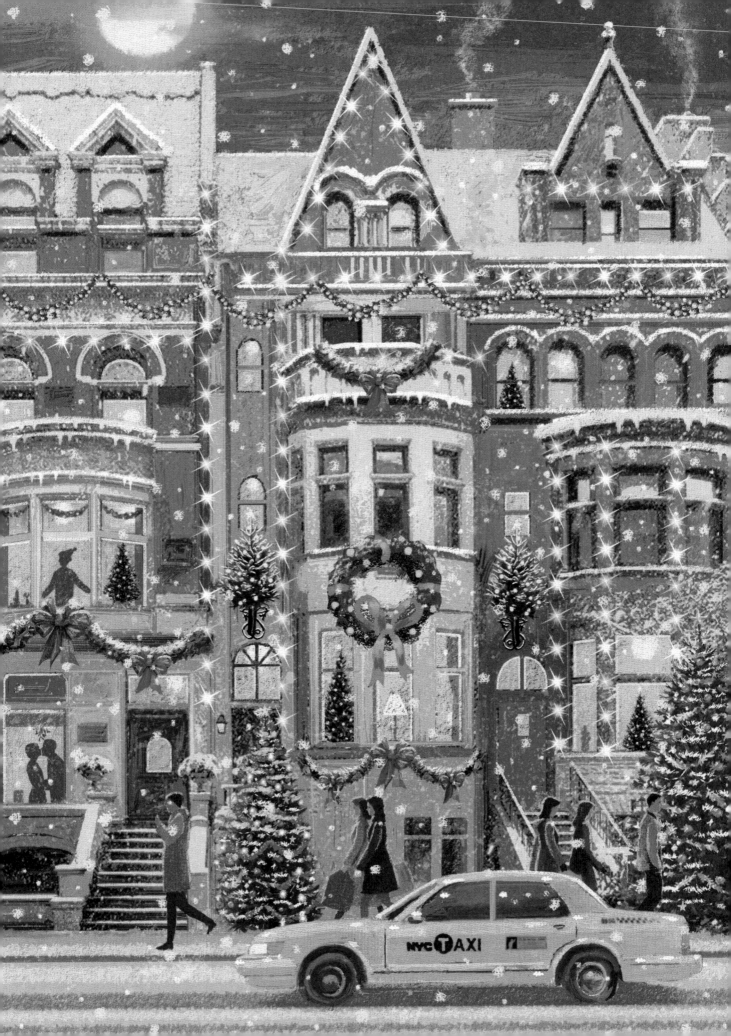

A Christmas Star

Anne Kennedy Brady

I was about seven years old when I turned to my mother and announced, "I really like being the center of attention." The topic of discussion had been which part I would receive in the children's Christmas musical at our local church. I was hoping for the juicy role of the archangel, who had the most lines and got to sing a beautiful solo. I ended up getting assigned to the role of a lesser angel who overcomes some minor anxiety in order to join the "heavenly host." No solo, but some great character work.

I continued to pursue theater into adulthood, stretching my wings beyond the holiday genre. However, some of my favorite work has always been Christmas-related. It's more than the familiar carols or the beautiful costumes. Being part of a Christmas play has always felt like being part of a universal story. The script itself may depict a contemporary holiday comedy of errors, a 19th-century change of heart, or a handful of Wise Men stumbling toward a distant star. The plots change. But tales of hope just seem to ring truer when they take place in the Christmas season. Stories of hardship inspire more hearts. And everyone's rooting for second chances.

And not just for those fictional characters! A surprise winter storm once delayed a fellow actor's travel, so that he didn't arrive at the theatre until the play had already started. He stepped onstage, shaking hands and exchanging places with the actor who had performed the first few scenes in

his stead, and the show continued as normal. The audience's response was a warm round of applause. In my experience, everyone wants to help a Christmas story get told—no matter the bumps along the way!

For several years, I was in a touring show that retold a classic holiday movie though improvisational comedy. Each year, in the weeks between Thanksgiving and Christmas, four of us would pile in a car and drive around western Washington to perform at all kinds of Christmas parties. It is by far the best gig I've ever had. And what made it so great was not the travel or the in-jokes among the cast or the livable paycheck, or even the fact that I met my husband on one tour (although that was a major perk). It was the shared celebration— a dozen times each year!—in the expectation, joy, and peace of the Christmas season. Our audiences ranged from corporate executives to church staff members to high school youth groups, and we got to rejoice in a story of hope and redemption with each and every one. What a privilege.

A couple years ago, my husband and I started attending a new church. One Sunday, a week or so before Christmas, the children's department presented a pageant. It was a far cry from the more elaborate musicals of my childhood. This production featured shaky readings of the Christmas scriptures from nervous middle schoolers, while the preschoolers and elementary kids haphazardly filed in to assume positions around a manger

scene. I was surprised to see some unfamiliar players in this version of the story. Mary and Joseph were there, of course, with whichever baby was newest in the congregation. I spotted a few angels and some bedraggled shepherds. But the animals varied slightly from St. Luke's account. A koala led the crowd with a butterfly traipsing proudly behind him. And while two or three sheep were mixed in with the menagerie, they were hard to see behind the princess and the panda bear. The pastor announced that they had decided to ensure every child who wanted to participate had a chance to join the celebration—whether or not a sheep costume was readily available. It remains one of my favorite expressions of the true meaning of Christmas because, after all, aren't we all welcome at this strange and wonderful party, no matter how we're dressed? If my son's giraffe costume from last Halloween still fits this year, we're signing him up!

I long ago stopped counting lines and comparing solos. Christmas plays, for me, are a chance to dive deep into the joy and redemption that this season begs us to remember. They allow me to celebrate with those who may be different from myself—those I might not otherwise have met. A shared story breaks down walls, connects our hearts, and asks us to love one another just a little more. What better way to get into the holiday spirit?

Image © Mark Scott/GAP Photos

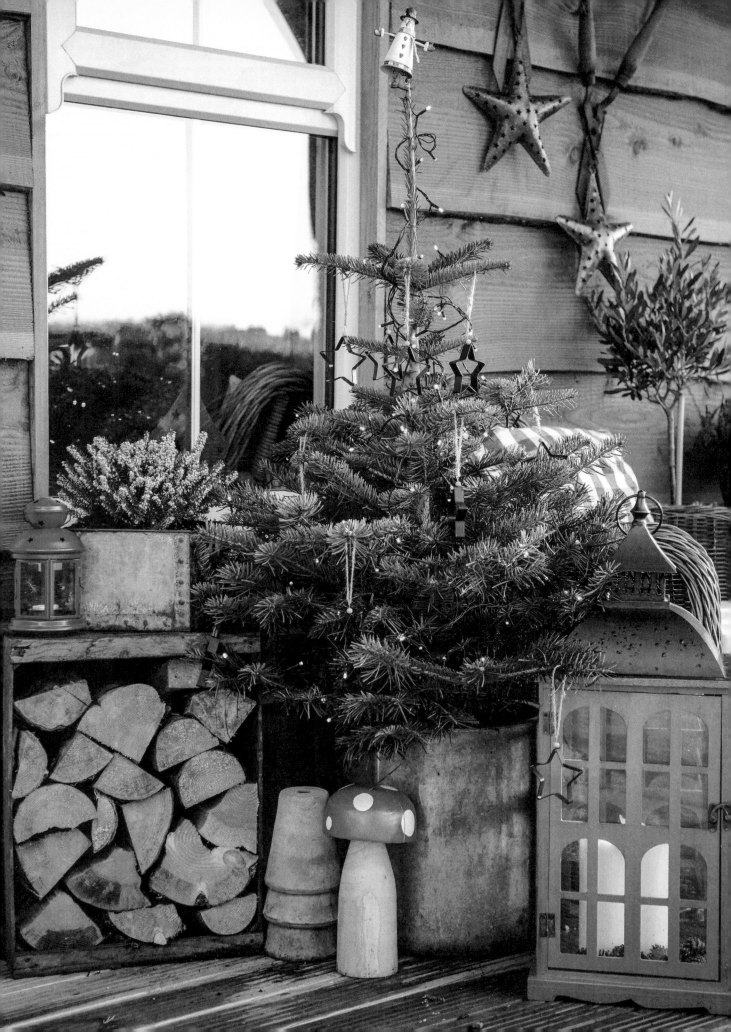

Christmas in the Heart
Unknown Author

It is Christmas in the mansion,
yule-log fires and silken frocks;
it is Christmas in the cottage,
mothers filling little socks.

It is Christmas on the highway,
in the thronging, busy mart;
but the dearest, truest Christmas
is the Christmas in the heart.

May Your Christmas Be Blessed
Mildred L. Jarrell

May your Christmas
 be blessed
with the joys of old,
filling the heart with
 gifts untold.
Friends at the doorway
bustling good cheer,
carolers singing the songs
 we hold dear.

May your Christmas
 be blessed
with the homiest things,
the warmth of a hearth,
 a kettle that sings,
a snug little house with
 loved ones near,
and a heart filled with blessings
to last through the year.

Christmas Cookies
Pamela Love

Up to our elbows in sugar
 and flour,
mixing and baking these treats
 by the hour.
Look at our aprons and you
 will soon see
marks of the cookies we're
 making with glee.

Bowl after bowl of delicious
 sweet dough,
scooped up and dropped out in
 row after row;
popped in the oven and in
 a short while
they can be wrapped in a
 gift-worthy pile.

Cookie-Baking Time
Reginald Holmes

We know it's almost Christmas
and it's cookie-baking time,
for Mother's in the kitchen
and the fragrance is sublime.
First she mixes up the batter,
full of sugar and of spice
and upon the kitchen table
rolls it out so flat and nice.

She takes the cookie cutters
and before our very eyes
we see both stars and animals
of every shape and size . . .

a Christmas tree and angels
and old Santa with a sleigh;
birds that look so natural
that they almost fly away.

For cookies are a specialty
that Mother loves to bake.
She covers them with icing
just like a birthday cake.
We always claim that Mother
is a cook who can't be beat . . .
her Christmas cookies always
make our holiday complete.

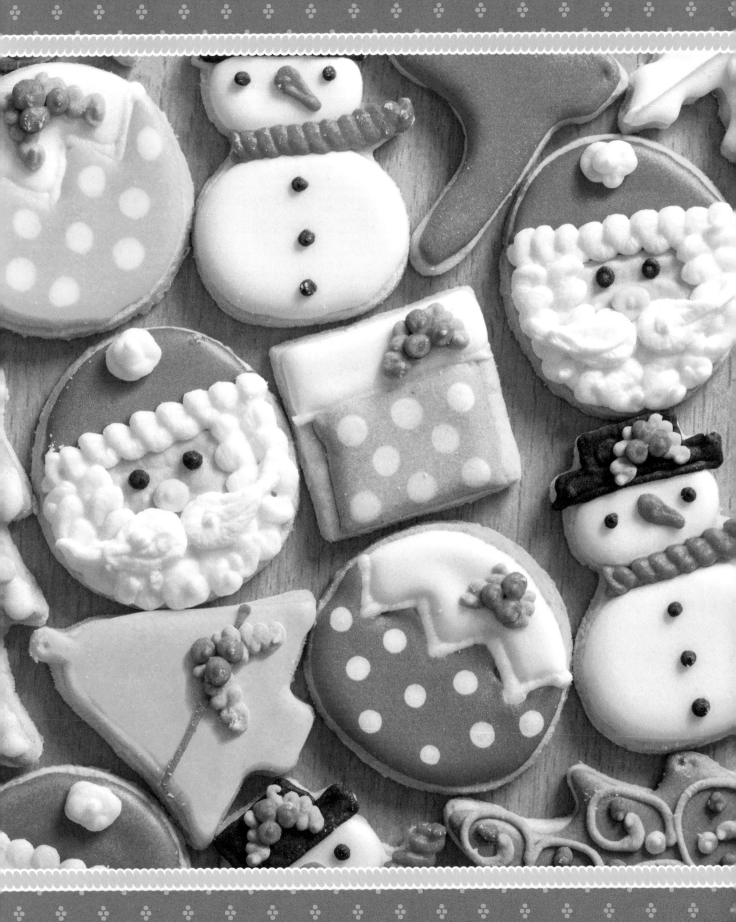

A New Taste of Christmas

Susan Sundwall

When I was a kid, my family of seven moved to Southern California, and my mom sorely missed our home in Minnesota. As Christmas approached, she hoped for a package from her family. We had no telephone, so any news from back home came by letter. One came from Grandma in the late fall. Mom grinned when she read it, telling us we'd be getting a package with gifts from Minnesota. We leaped for joy. As soon as Thanksgiving was over, we began stalking the mailman. Day after day, though, our hopes were dashed—not only did we have no snow, but there didn't seem to be a package coming, either.

Dad gets the credit for keeping our spirits up. He came home from the Christmas tree lot one Saturday and pulled a small pine tree through the front door of our rented home. As he clipped the lower branches to fit it into its red and green stand, the scent of pine resin filled our small living room. We kids were all over him as he attempted to erect this iconic symbol of the season. He'd also bought a few strings of colored glass lights—the kind that got hot if you left them on too long. Lead foil icicles were ten cents a box and we painstakingly pulled them apart to drape onto the tree branches. Dad insisted they go on one at a time but we quickly tired of that. When he wasn't looking, we'd let them fly. It was a shimmering monument to discipline and mayhem, all in one tree.

But we longed for that package from home. At last the mail truck came down the street and stopped at our house. The mailman pulled out a string-tied package and came up our walk. Oh, the joy! Mom tried to be dignified while her five children leaped around her like demented elves. She thanked the man and closed the door. "It's from Minnesota," she said, reading the return address. Her mom, our Grandma Blaine, and our dad's sister, Aunt Dee, had come through.

We peered excitedly into the large box as the paper was torn off and the contents were revealed. Pretty packages tied with curled ribbon had tags with our names on them. Mom read the tags and handed us our gifts. We held them for a bit and shook them to guess what was inside. Then they'd go into her closet until Christmas Eve. But there was more. Grandma had included ribbon candy, and there was a big bag of mixed nuts with a nutcracker for Dad from his sister. Then, there was something wrapped in aluminum foil, tied with red ribbon.

"I hope this is your Aunt Dee's date-nut bread," Mom said gleefully.

And it was. She removed the wrappings to reveal a dark, slightly sticky looking loaf. *Dates?* I thought. *Yuck.* Like most kids, I distrusted new foods, especially anything bearing even a passing resemblance to something healthy.

We had another week of school left. One day I came home a famished child wanting

something sweet. The only thing around was Aunt Dee's date-nut bread. I groaned. "It's really good," Mom coaxed. "Dates are very sweet."

I made a face looking at it. *Maybe.*

"I'll put some butter on. Want to try it?"

Famished children do odd things. I agreed. She slathered a small slice with butter and gave it to me with a glass of milk. My first tentative bite tasted good, and the dark, date-loaded slice seemed exotic, like something the three Wise Men might eat. I took another bite and kept going until I finished. I grinned.

"Your tastes are maturing," Mom said.

I think that was a bit of psychology she was slinging at me there. Every little girl wants to be thought older. I took the bait and asked for another slice.

Mom's heart was full of gratitude that year. The package from home had helped smooth her transition to a new place. She begged the recipe from Aunt Dee, and for years afterward our kitchen was filled with the sweet, rich smell of date-nut bread baking at Christmastime.

Now, I bake it each year using my own copy of the recipe. Our oldest son loves it, but his young daughter thinks it's "yucky." Maybe one Christmas she'll come to visit famished. I'll be ready for her with a gooey piece of buttered date-nut bread and a big glass of milk.

Christmas Date-Nut Bread

1 8-ounce package whole pitted dates, finely chopped	1 egg
	1 teaspoon vanilla
1 teaspoon baking soda	1⅔ cups all purpose flour
1 cup hot water	½ teaspoon salt
¼ cup shortening	½ cup chopped walnuts
1 cup granulated sugar	

Preheat oven to 350°F. Grease and lightly flour a loaf pan. In a large bowl, sprinkle dates with baking soda. Pour hot water over dates; set aside about 5 minutes. In a medium mixing bowl, combine shortening, sugar, egg, and vanilla. In a separate bowl, stir together flour and salt. Add both mixtures to dates, stirring in alternately. Fold in walnuts and turn into loaf pan. Bake 60 minutes or until a knife inserted in center comes out clean. Makes 1 loaf.

Family Recipes

Cranberry-Glazed Pork Roast

3 teaspoons cornstarch
¼ teaspoon ground cinnamon
⅛ teaspoon salt
6 tablespoons orange juice

1 16-ounce can whole berry
 cranberry sauce
1 3- to 5-pound boneless pork loin

Preheat oven to 500°F. In a small saucepan, combine cornstarch, cinnamon, and salt. Stir in orange juice and cranberry sauce and cook over medium heat, stirring, until thickened. Set aside. In a shallow roasting pan, cover pork with half of cranberry mixture. Roast 10 minutes. Reduce oven to 250°F and roast, basting occasionally with remaining cranberry mixture, until a meat thermometer inserted in the thickest part of the meat registers 150°F, 1 to 1½ hours. Remove from oven and allow to rest 10 minutes before serving. Makes 8 to 10 servings.

Rosemary Roasted Potatoes

2 pounds (5 to 6 medium)
 thin-skinned potatoes,
 cut into 1-inch cubes
3 tablespoons extra-virgin olive oil

1 tablespoon dried or 2 tablespoons
 minced fresh rosemary
2 teaspoons kosher salt

Preheat oven to 425°F. Line a shallow baking sheet with foil or a nonstick baking mat. In a large bowl, toss potatoes with olive oil, rosemary, and salt, making sure potatoes are evenly coated with oil. Spread on baking sheet. Bake 40 to 50 minutes, stirring every 15 minutes, until potatoes are golden. Remove from oven and serve hot. Makes 6 to 8 servings.

Festive Cranberry Salad

- 1 10-ounce package mixed salad greens
- 1 medium apple, diced
- ½ cup shredded Parmesan cheese
- ½ cup dried cranberries
- ½ cup slivered toasted almonds
- ½ cup fresh or frozen cranberries, thawed
- ¼ cup granulated sugar
- 3 tablespoons cider vinegar
- 2 tablespoons thawed apple juice concentrate
- ½ teaspoon salt
- ½ teaspoon ground mustard
- ½ teaspoon grated onion
- ½ cup olive oil

In a large bowl, combine salad greens, apple, Parmesan cheese, dried cranberries, and almonds. Set aside. In a blender, place cranberries, sugar, vinegar, apple juice, salt, ground mustard, and onion. Cover and pulse until well blended. While processing, gradually add oil in a steady stream. Pour desired amount of dressing over salad and toss to coat. Refrigerate any leftover dressing. Makes 6 to 8 servings.

Cranberry Nut Bars

- 2 eggs
- 1 cup granulated sugar
- 1 cup all-purpose flour
- ⅓ cup butter, melted
- 1¼ cups fresh or frozen cranberries, thawed
- ½ cup chopped walnuts

Preheat oven to 350°F. Grease an 8- or 9-inch baking pan. In a medium mixing bowl, beat eggs until thick. Gradually add sugar and beat until thoroughly blended. Stir in flour and melted butter until well incorporated. Gently fold in cranberries and walnuts just until combined. Spread batter in prepared pan. Bake 40 to 45 minutes or until golden brown and a toothpick inserted into the center comes out clean. Cool and cut into bars. Makes 16 servings.

Christmases of Childhood

Deana Johnson

Sugarplum visions,
candy-cane dreams—
Christmas spirit
 returns
like magic, it seems.

Frosted windows,
candles bright,
tinseled trees, and
twinkling lights.

Friendly greetings,
warm embraces,

children's smiles, and
glowing faces.

Christmas story,
angels singing,
brightest star,
carols ringing.

Precious memories,
nostalgia's refrain—
Christmases of
 childhood
forever remain.

December: month of holly,
pine, and balsam; of berries red;
of candles' mellow light;
of home and fireside, laughter,
happy faces; of peace that
comes upon the holy night.

—AUTHOR UNKNOWN

Image © Nestyda/Shutterstock

Christmas Song
Lydia A. C. Ward

Why do bells for Christmas ring?
Why do little children sing?

Once a lovely, shining star,
seen by shepherds from afar,
gently moved until its light
made a manger-cradle bright.

There a darling Baby lay
pillowed soft upon the hay.
And his mother sang and smiled,
"This is Christ, the holy Child."

So the bells for Christmas ring;
so the little children sing.

Hope Flames High
Vera Hardman

When the holly's in the window
and the Christmas stars are bright,
then we gather round our Christmas tree
with hearts so gay and light;
and on the crisp, cold air there come
voices sweet and clear,
caroling the Christmas songs
that to our hearts are dear.

Then the bells take up the chant
and chime so soft and low,
as they tell the Christmas story—
the holy night of long ago.
And as the candles gleam and burn
and the hearthfire glows,
hope flames high, and in our hearts
the Christmas spirit grows.

Three Symbols of Christmas

Billy Graham

There are three symbols which mean Christmas—the real meaning of Christmas.

The first is the cradle. In words so familiar to us all, the Bible describes God in human flesh! In the person of a tiny infant! There, in Bethlehem, were cradled the hopes and dreams of a dying world. Those chubby little hands that clasped the straw in His manger crib were soon to open blind eyes, unstop deaf ears, and still the troubled seas. Those tiny feet were to take Him to the sick and needy and were to be pierced on Calvary's cross.

That manger crib in remote Bethlehem became the link that bound a lost world to a loving God.

The cross. There were both light and shadow on that first Christmas. There was joy with overtones of sadness, for Jesus was born to die. Jesus, approaching the cross, said, "To this end was I born, and for this cause came I into the world." To Christians the joy of Christmas is not limited to His birth. It was His death and Resurrection that gave meaning to His birth.

It is in the cross that the world can find a solution to its pressing problems.

The crown. Jesus was crowned with a crown of thorns and enthroned on a cruel cross, yet His assassins did something, perhaps unwittingly. They placed a superscription over His cross in Greek, Latin, and Hebrew: "This is the King."

Yes, Christ is King of kings and Lord of lords, and He is coming back someday. He will come not as a Babe in Bethlehem's manger. The next time He comes it will be in a blaze of glory and He will be crowned Lord of all.

Cradle—cross—crown. Let them speak to you. Let the power of Him who came to us at Christmas grip you, and He will surely change your life.

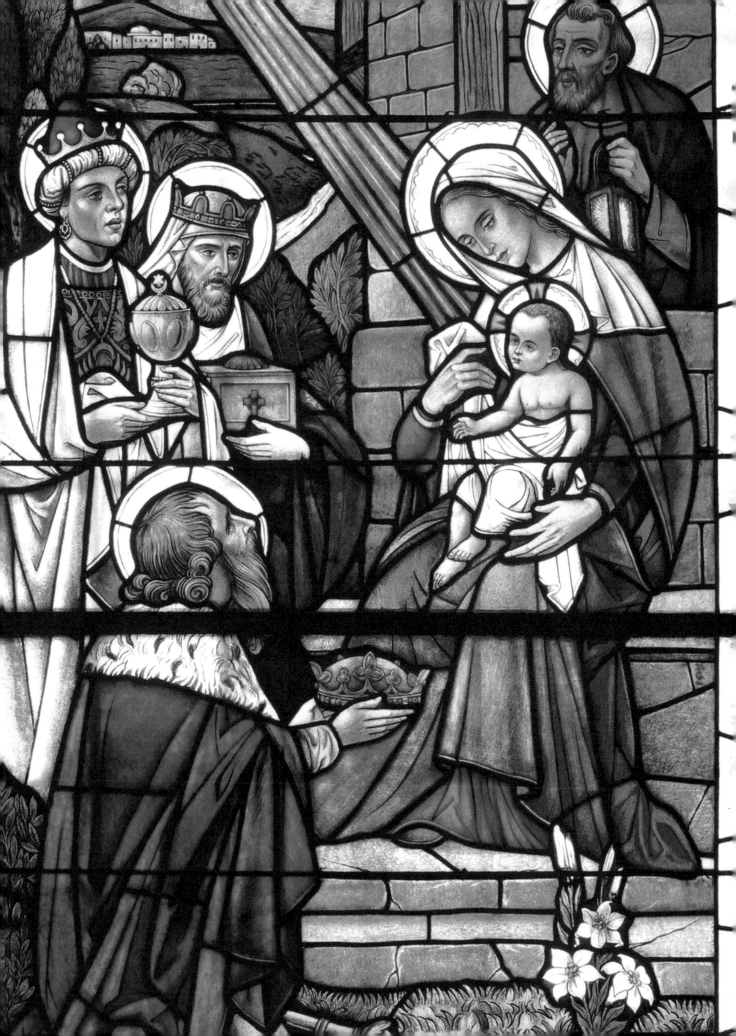

The Story of a Song

The Friendly Beasts

Pamela Kennedy

The biblical account of the night Jesus was born is remarkably brief: "So it was, that while they were there, the days were completed for her to be delivered. And she brought forth her first-born Son, and wrapped Him in swaddling cloths, and laid Him in a manger, because there was no room for them in the inn" (Luke 2:6–7, NKJV).

Traditionally, artists have rendered the scene in a dimly lit stable or cave, illuminated by a single shining star. Joseph and Mary flank a small straw-filled wooden feeding trough where the Christ Child sleeps, snuggled in swaddling cloths. Most often, in the background of the painting, animals gaze adoringly at the baby.

This bucolic scene no doubt seemed too simple for the tastes of early Christians, who preferred to embellish the stories of Christ's birth and childhood with miraculous elements. One of the oldest and most popular legends concerns the animals present at the Nativity. It maintains that at midnight on that first Christmas Eve, the power and presence of God enabled the animals to speak with human voices, so that they might praise and worship the infant Jesus. Over time, other stories added more intriguing details. One

Medieval tale even recounts a conversation in Latin between a rooster, a raven, a sheep, and a donkey concerning the time and place of Christ's birth! Perhaps this explains why many people still claim that at midnight on Christmas Eve animals are briefly given the gift of speech.

Originating in 12th-century France, the carol "The Friendly Beasts" draws upon this rich tradition of folklore. In its verses, five animals describe the gifts they gave to the holy family. The donkey tells how he carried Mary safely to Bethlehem. The cow notes his donation of both manger and hay. The sheep contributed wool for a warm blanket. The dove, along with her mate, sang a lullaby. And the camel carried the Magi and their precious gifts. In the 1920s, centuries after the carol's origin, Robert Davis composed the words to our current English version.

The enduring popularity of this carol may be attributed not only to its intriguing theme about talking animals, but also to a widespread conviction that there exists a mystical connection between Creator and Creation. Long ago in Bethlehem, through the miracle of the incarnation, Christ became God's tangible love gift to the world. On that night, divinity touched the earth and it seems not only possible, but also somehow natural that all creatures would respond with gratitude and joy.

The Friendly Beasts

Robert Davis

Traditional French

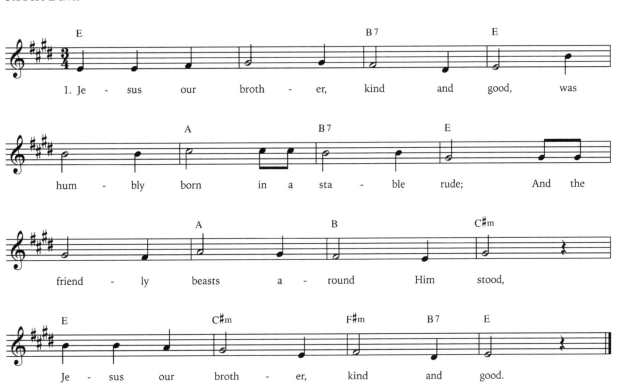

1. Je - sus our broth - er, kind and good, was
hum - bly born in a sta - ble rude; And the
friend - ly beasts a - round Him stood,
Je - sus our broth - er, kind and good.

2. "I," said the Donkey, shaggy and brown,
 "I carried His mother up hill and down;
 I carried her safely to Bethlehem town.
 "I," said the Donkey, shaggy and brown.

3. "I," said the Cow, all white and red,
 "I gave Him my manger for His bed;
 I gave him my hay to pillow his head.
 "I," said the Cow, all white and red.

4. "I," said the Sheep, with curly horn,
 "I gave Him my wool for His blanket warm;
 He wore my coat on Christmas morn.
 "I," said the Sheep, with curly horn.

5. "I," said the dove from the rafters high,
 "I cooed Him to sleep so He would not cry;
 We cooed him to sleep, my mate and I.
 "I," said the dove from the rafters high.

6. "I," said the Camel, all yellow and black,
 "O'er the desert, upon my back,
 I brought Him a gift in the Wise Men's pack.
 "I," said the Camel, all yellow and black.

7. Thus every beast by some good spell,
 In the stable dark was glad to tell
 Of the gift he gave Immanuel,
 The gift he gave Immanuel.

The Birth in Bethlehem

Luke 2:1–7

AND IT CAME TO PASS in those days, that there went out a decree from Caesar Augustus that all the world should be taxed. (And this taxing was first made when Cyrenius was governor of Syria.) And all went to be taxed, every one into his own city.

And Joseph also went up from Galilee, out of the city of Nazareth, into Judaea, unto the city of David, which is called Bethlehem; (because he was of the house and lineage of David:) To be taxed with Mary his espoused wife, being great with child. And so it was, that, while they were there, the days were accomplished that she should be delivered. And she brought forth her firstborn son, and wrapped him in swaddling clothes, and laid him in a manger; because there was no room for them in the inn.

ADORATION OF THE SHEPHERDS *by Jacques Stella.*
Image © Jacques Stella/Bridgeman Images

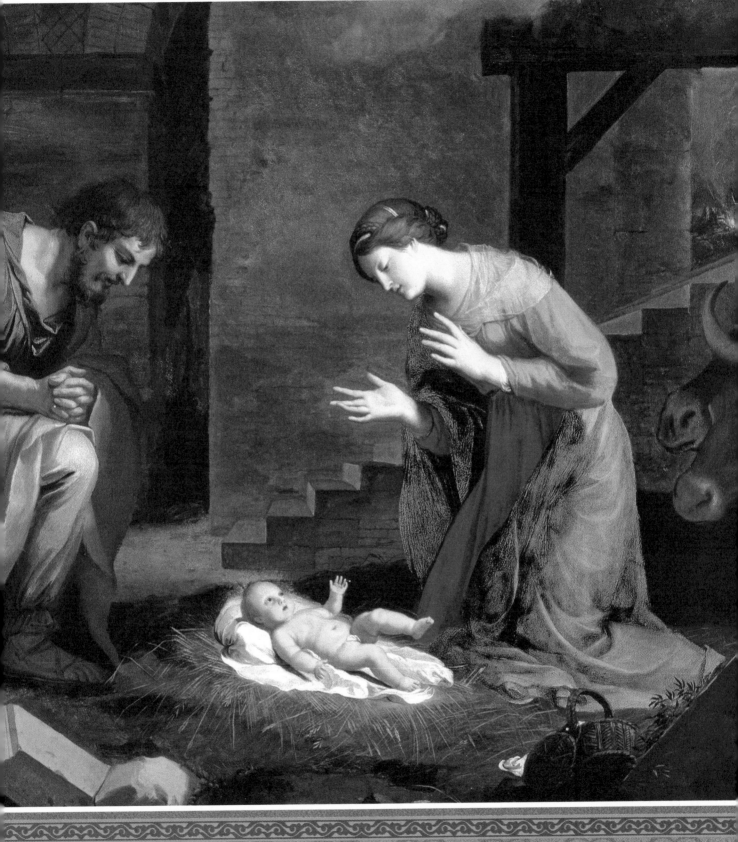

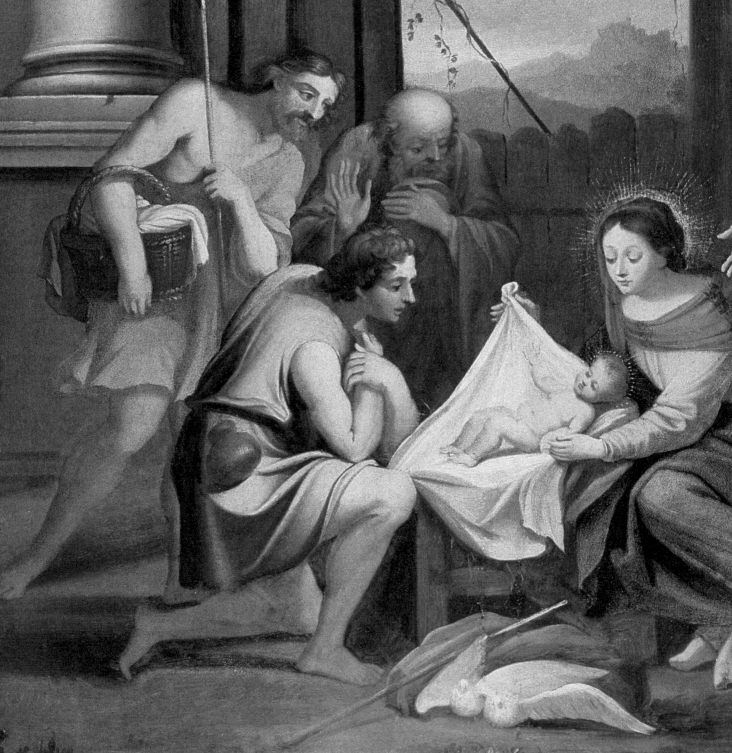

SHEPHERDS AND ANGELS
Luke 2:8–14

AND THERE WERE in the same country shepherds abiding in the field, keeping watch over their flock by night. And, lo, the angel of the Lord came upon them, and the glory of the Lord shone round about them: and they were sore afraid. And the angel said unto them, Fear not: for, behold, I bring you good tidings of great joy, which shall be to all people. For unto you is born this day in the city of David a Saviour, which is Christ the Lord. And this shall be a sign unto you; Ye shall find the babe wrapped in swaddling clothes, lying in a manger.

And suddenly there was with the angel a multitude of the heavenly host praising God, and saying, Glory to God in the highest, and on earth peace, good will toward men.

THE NATIVITY *by Jacques Stella.*
Image © Jacques Stella/Bridgeman Images

THE WISE MEN

Matthew 2:1–12

NOW WHEN JESUS was born in Bethlehem of Judaea in the days of Herod the king, behold, there came wise men from the east to Jerusalem, saying, Where is he that is born King of the Jews? for we have seen his star in the east, and are come to worship him.

When Herod the king had heard these things, he was troubled, and all Jerusalem with him.

Then Herod, when he had privily called the wise men, enquired of them diligently what time the star appeared. And he sent them to Bethlehem, and said, Go and search diligently for the young child; and when ye have found him, bring me word again, that I may come and worship him also.

When they had heard the king, they departed; and, lo, the star, which they saw in the east, went before them, till it came and stood over where the young child was. When they saw the star, they rejoiced with exceeding great joy. And when they were come into the house, they saw the young child with Mary his mother, and fell down, and worshipped him: and when they had opened their treasures, they presented unto him gifts; gold, and frankincense and myrrh. And being warned of God in a dream that they should not return to Herod, they departed into their own country another way.

ADORATION OF THE MAGI *by Jacques Stella.*
Image © Jacques Stella/Bridgeman Images

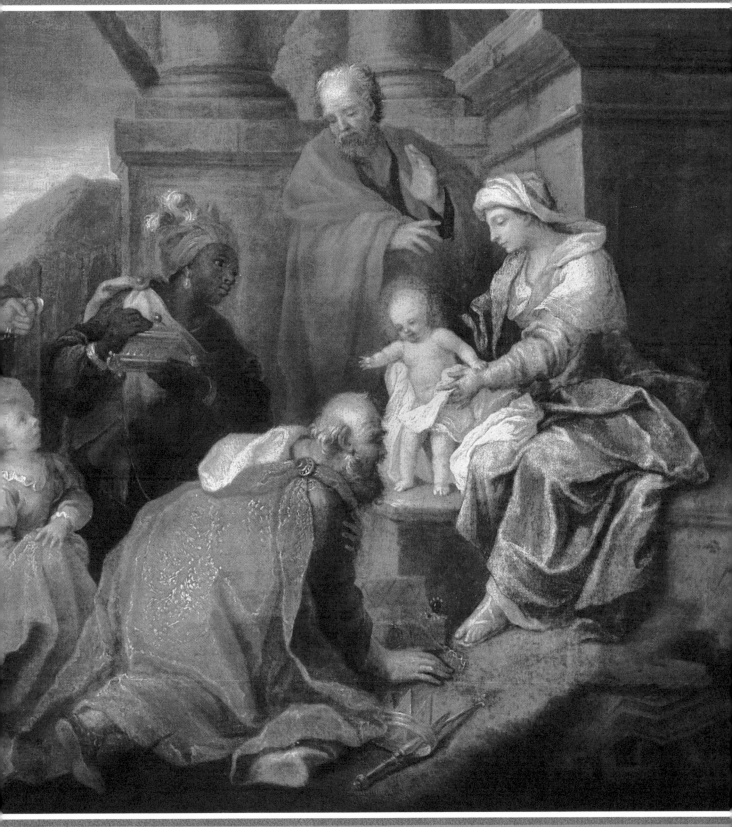

A Christmas Carol
Alice Sewell

The night was darker than ever before
 (so dark is sin)
when the Great Love came
 to the stable door
and entered in

and laid Himself in the breath of kine
and the warmth of hay,
and whispered to the star to shine,
and to break, the day.

STAR HIGH, BABY LOW:
'TWIXT THE TWO, WISE MEN GO;
FIND THE BABY, GRASP THE STAR—
HEIRS OF ALL THINGS NEAR AND FAR!
—*George MacDonald*

A Christmas Folk Song
Lizette Woodworth Reese

The little Jesus came to town;
the wind blew up, the wind blew down;
out in the street the wind was bold;
now who would house Him from the cold?

Then opened wide a stable door,
fair were the rushes on the floor;
the ox put forth a horned head:
"Come, little Lord, here make Thy bed."

Uprose the sheep were folded near:
"Thou Lamb of God, come, enter here."
He entered there to rush and reed,
who was the Lamb of God indeed.

The little Jesus came to town;
with ox and sheep He laid Him down;
peace to the byre, peace to the fold,
for that they housed Him from the cold!

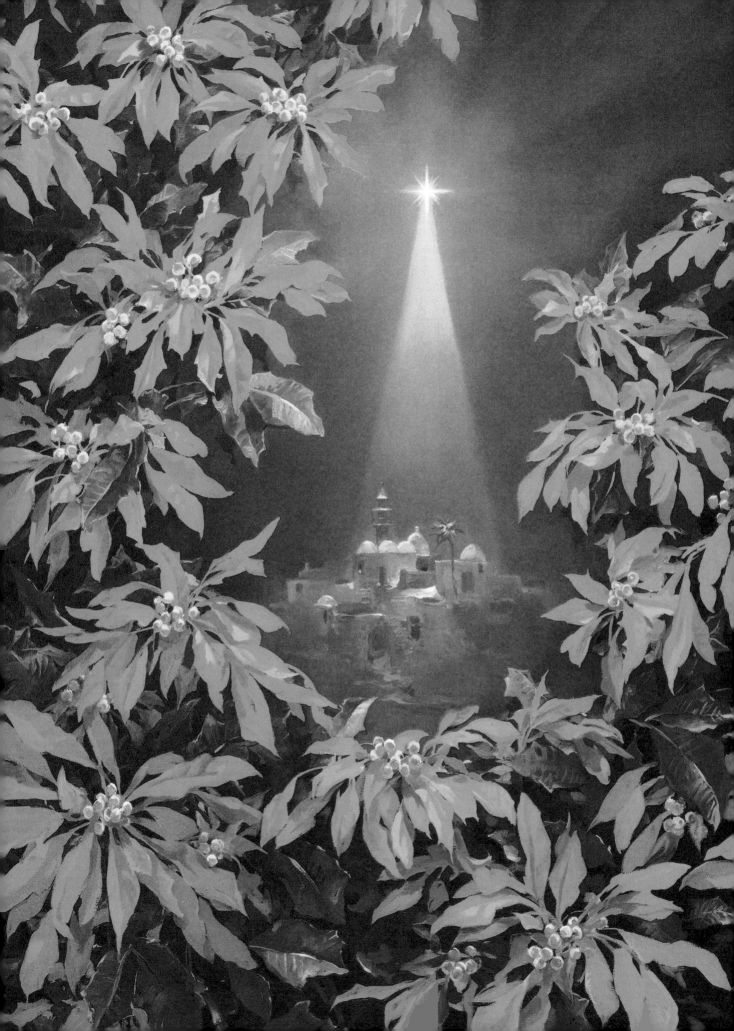

Through My Window

A Long Ways from the Manger

Pamela Kennedy

The first year my husband and I were married, my mother bought us a Nativity set. Made of rough wood, it had bits of moss glued on the sides and roof and featured three Wise Men, a shepherd, Joseph, Mary, Baby Jesus, a little cradle, three sheep, one donkey, and a cow. The figures were plastic and painted to look more like sixteenth-century European gentry than first-century Middle-Eastern refugees. Mary's blue robe matched her eyes, Joseph held a rustic lantern, and baby Jesus was blonde. My mother's intent was that we would begin our own Christmas traditions, making memories along the way. It was almost fifty years ago when she gave us the Nativity set, and it would be six years before we had our first child. But my mother, bless her heart, knew what she was doing.

When our first son was about two and a half, he noticed the manger scene where I had placed it on a low bookcase. I told him the Christmas story, using the small figures to demonstrate their parts in the biblical narrative. Thereafter I would find him driving the shepherd and his sheep up to the stable in his toy dump truck, dumping them out, then heading off to gather up the donkey and cow. The Wise Men arrived via airplane. In his retelling, they always got there "right on time." This monologue might have reflected his mother's obsession with not being late, as I was constantly urging him to get ready "on time."

When our second son was nearing his third birthday, he loved placing all the figures in a circle around Baby Jesus. It seemed he didn't want any of them to miss out on such a spectacular child. I suspect his concern arose from misunderstanding the lyrics of one of his favorite carols to be "A Ways from the Manger." In his arrangement of the Nativity scene, no one was "a ways from the manger"!

Our third child, a daughter, had a penchant for realism and also for drama. During the Christmas season, I often found the three Wise Men lined up on the piano, across the room from the manger scene. When I asked her about this, she replied that her Sunday school teacher had told them that, *actually*, the Wise Men didn't get there until much later, since they had to travel so far. So *obviously*, they wouldn't be there along with the shepherds (cue rolling eyes).

I loved sharing these little stories with my mother, who would simply nod her head. "They're making memories," she'd say with a smile.

My husband and I have moved twenty times in the fifty years of our marriage. Lots of things got lost, broken, or replaced, but the little Nativity set somehow survived. It did, however, get stashed away in storage for a few years. Then this past Christmas I found it tucked in the bottom of a box of old decorations. I decided to dust

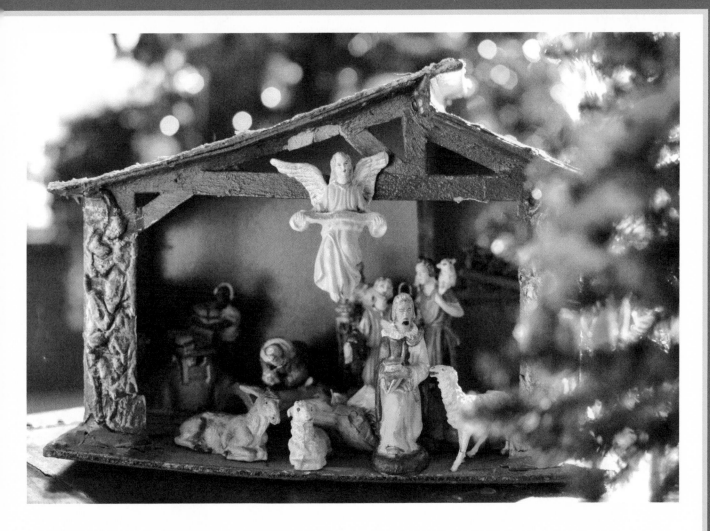

it off and set it up at our beach house where we now celebrate Christmas with our grown children and their families. Our youngest grandchild, Milo, was two and a half, and it was the first time he had seen this manger set. He has one at his own house, however, so he was familiar with the characters. One chilly afternoon, he came over to me with a piece of tissue paper he'd found in an abandoned gift box.

"Baby Jesus too cold. Grammy fix," he ordered. Then he took my thumb and walked me over to the manger scene, set up on a low table. He ran off and returned with a roll of tape. "Here."

"Do we need to help Baby Jesus?" I asked.

"Yep," he replied.

Together we tore a small piece of paper, carefully swaddled the baby, and secured the tissue with a piece of tape.

"This guy cold too," he added, handing me the shepherd. By the time we finished, we had crafted capes and blankets for many of the main players at the manger. Milo was satisfied.

A week later, after everyone had left and I was tidying up the house, I came to the Nativity set with its tissue-clad characters. A wave of nostalgia swept over me. My mother passed away over ten years ago and she never met her great-grandchildren, but I could almost see her smile. She was right. In small and large things, words and memories, traditions weave through and connect the generations. So when we gather together at Christmas, we are never a long ways from the manger.

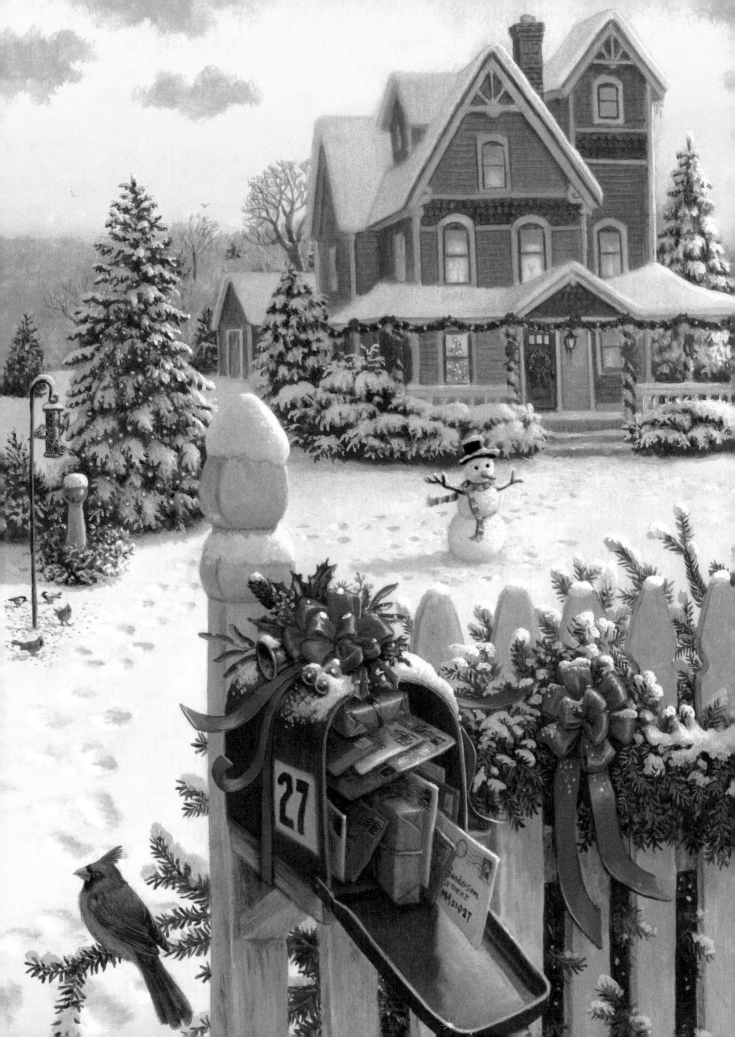

It Isn't Far to Bethlehem

J. Harold Gwynne

It isn't far to Bethlehem
where lies the newborn King;
it isn't far to Bethlehem
where holy angels sing.

The Wise Men saw the guiding star
that led them where He lay;
the shepherds heard the heavenly song
that brought the better day.

We too may go to Bethlehem
and find the Savior Child;
we too may hear the angels sing
their hymns of mercy mild.

Our hearts are God's new Bethlehem,
where Christ is born anew.
It isn't far to Bethlehem
if He is born in you.

The Waits

Margaret Deland

At the break of Christmas Day,
through the frosty starlight ringing,
faint and sweet and far away,
comes the sound of children, singing,
chanting, singing,
"Cease to mourn,
for Christ is born,
peace and joy to all men bringing!"

Careless that the chill winds blow,
growing stronger, sweeter, clearer,
noiseless footfalls in the snow,
bring the happy voices nearer;
hear them singing,
"Winter's drear,
but Christ is here,
mirth and gladness with Him bringing."

"Merry Christmas!" hear them say,
as the East is growing lighter;
"May the joy of Christmas Day
make your whole year gladder, brighter!
Join their singing,
to each home
our Christ has come,
all love's treasures with Him bringing!"

Bits & Pieces

Christmas is a bridge. We need bridges as the river of time flows past. Today's Christmas should mean creating happy hours for tomorrow and reliving those of yesterday.
—*Gladys Taber*

Christmas is the perfect time to celebrate the love of God and family and to create memories that will last forever.
—*Joel Osteen*

The smells of Christmas are the smells of childhood.
—*Richard Paul Evans*

Happy, happy Christmas, that can win us back to the delusions of our childish days, recall to the old man the pleasures of his youth, and transport the traveler back to his own fireside and quiet home!
—*Charles Dickens*

Our hearts grow tender with childhood memories and love of kindred, and we are better throughout the year for having, in spirit, become a child again at Christmastime.
—*Laura Ingalls Wilder*

Christmas means a great deal to me. I was reared in a family that celebrated Christmas to some extent, but I married into a family that celebrated Christmas in a big way. And my wife always made a big thing of Christmas for the children. We have five children, and we had a terrific time at Christmas.

—Billy Graham

Faith is salted and peppered through everything at Christmas. And I love at least one night by the Christmas tree to sing and feel the quiet holiness of that time that's set apart to celebrate love, friendship, and God's gift of the Christ Child.

—Amy Grant

When I was five years old, my parents gave me a drum set for Christmas. My mom played the piano, and Dad played the saxophone badly. But that Christmas morning, I remember we all played together, and I thought it was the greatest day ever.

—Garry Marshall

When we recall Christmas past, we usually find that the simplest things—not the great occasions—give off the greatest glow of happiness.

—Bob Hope

Each Christmas finds me longing for Christmases now past, and I am back in childhood as long as memories last.

—Carice Williams

The Christmas Long Ago
James Whitcomb Riley

Come, sing a hale Heigh-ho
for the Christmas long ago!—
when the old log-cabin homed us
from the night of blinding snow,
where the rarest joy held reign,
and the chimney roared amain,
with the firelight like a beacon
through the frosty windowpane.

Ah! the revel and the din
from without and from within,
the blend of distant sleigh bells
with the plinking violin;
the muffled shrieks and cries—
then the glowing cheeks and eyes—
the driving storm of greetings,
gusts of kisses and surprise.

Christmas As It Used to Be
E'lane Carlisle Murray

Across the shadowed room, still bright
against the dark, enclosing night,
is a fire with curling smoke,
crackling with mesquite and oak.

In a corner, cool and dim,
its branches bright with tinsel trim,
standing straight for all to see
is the cedar Christmas tree.

Above each door, with ribbons red,
sprigs of mistletoe are spread.
Soft green leaves and berries white
reflect the candles' golden light.

Long brown stockings in a row,
dark against the golden glow,

hang near the soft and gray ash bed
warmed by embers burning red.

Dreams that in each stocking toe
a golden orange is sure to go!
And crammed with wonders to the top,
their ribbed expanse will all but pop.

Between these treasures, here and there,
pecans and walnuts everywhere,
and brightly striped in red and white,
sweet sticks of peppermint to bite.

Years pass, yet memories stay
and never wholly go away.
I can close my eyes and see
Christmas as it used to be.

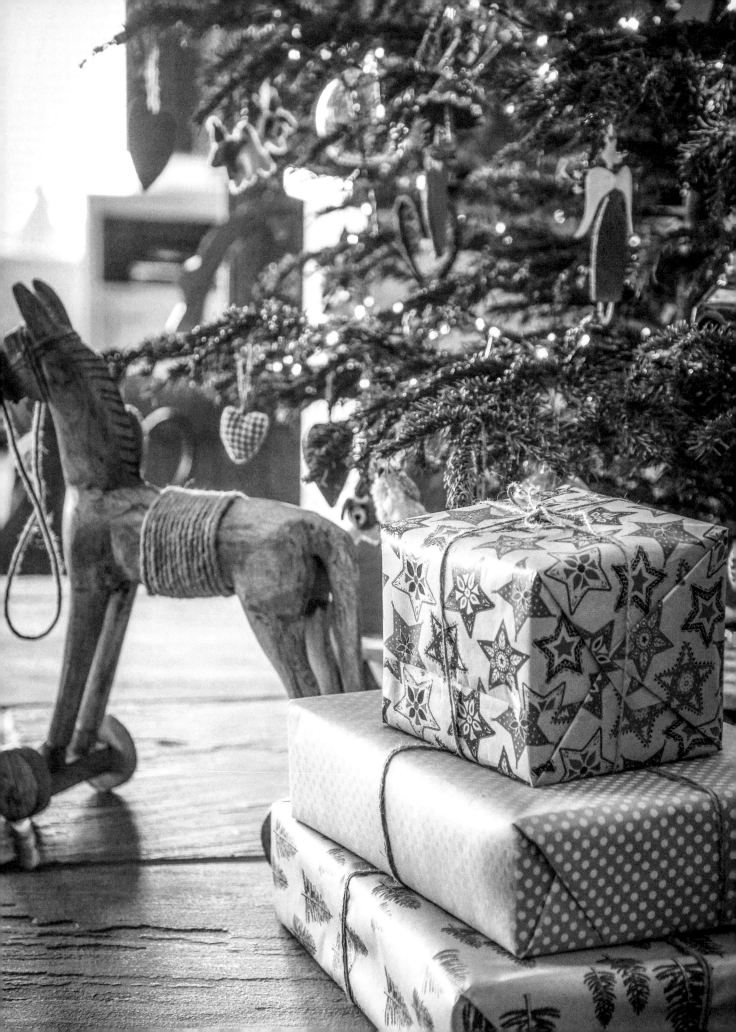

CHRISTMAS IDEALS
Through the Years

The first issue of *Ideals* was published in 1944. In the seventy-five years since, we have published a Christmas issue every year. You can see that long tradition in this sampling of Christmas covers from throughout the years. And in the pages that follow, you can read the story of *Ideals* and enjoy pages from past issues, which reflect the changing times and styles of the intervening decades.

1944

The 1940s

1945

1947

1949

The 1950s

1950

1951

1953

1956

1957

The 1960s

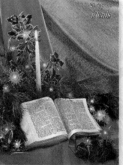

1961

1962

1964

1965

1969

The 1970s

1970

1973

1974

1977

The 1980s

1981

1982

1983

1987

The 1990s

1990

1991

1995

1999

2000—Present

2002

2004

2012

2016

ideals®

A Long History of Inspiration and Tradition

Ideals was conceived more than seventy-five years ago in Milwaukee, Wisconsin, by Van B. Hooper, a public relations manager for a local manufacturer. Hooper began by collecting bits and pieces of poetry and homespun philosophy to add to the company newsletter. Employee response was enthusiastic; before long, workers were sharing the newsletter with friends and family members. Soon, Hooper was mailing his newsletter to readers throughout the Milwaukee area and beyond.

In 1944, Mr. Hooper decided to turn his newsletter into a magazine, with each and every page devoted to the kind of uplifting poetry and stories that he had been sharing alongside items of company news. He chose the name *Ideals* for his fledgling magazine and, in September of 1944, went to press with the very first Christmas issue.

In the early years, the magazine earned new subscribers through word of mouth alone. Readers were eager for the kind of old-fashioned, homespun values that Mr. Hooper's magazine espoused. *Ideals* grew, eventually expanding to eight issues a year mailed throughout the United States and Canada. The magazine remained a Hooper family venture for almost thirty-five years until 1977, when Mr. Hooper's heir sold the company to a larger publishing company. The foundation laid by Van Hooper was a strong one, however, and the tradition of *Ideals* was respected by the new publishers.

Today the magazine is published from offices near Nashville, Tennessee, far away from its Milwaukee roots, but little removed from the intent behind Mr. Hooper's first newsletters. *Ideals* is treasured by readers who believe that no matter how times change, the simple things— family ties, love of country, and faith in God— are what see us through.

Throughout the years, various issues of *Ideals* have each focused on a specific theme, from the celebration of traditional holidays, rural life, nostalgia, patriotism, and friendship to the changing seasons of the natural world. *Ideals'* most popular issues are still published at Christmastime and Easter. These annual holiday issues are sought out by readers who appreciate Mr. Hooper's mission to create "a book of old-fashioned ideals, homey philosophy, poetry, music, inspiration, and art."

In this anniversary issue, we celebrate the seventy-fifth year of *Ideals* with a collection of text, artwork, and photos from throughout the decades. We invite you to look back with us through the years. Each poem, story, and quotation is as it appeared originally, and although you may laugh at a phrase or marvel at how times have changed, we believe you will also find that the words that inspired, amused, and comforted *Ideals* readers all those years ago, more often than not, do the same today. The important things remain the same through the years.

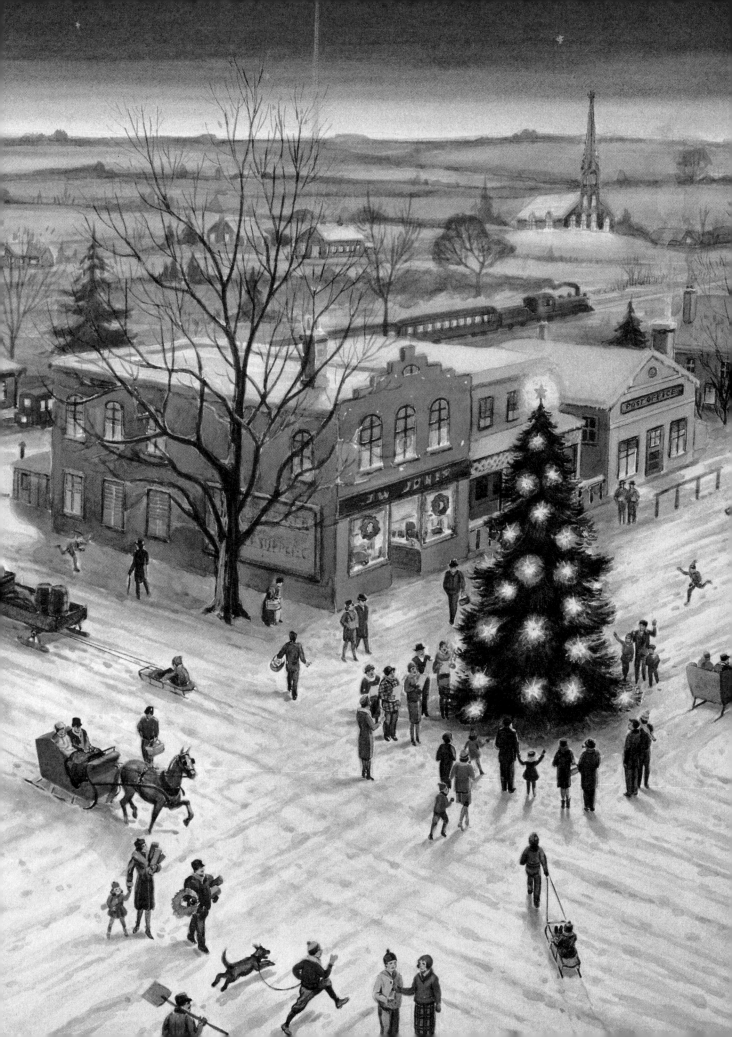

This Time of Year

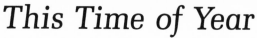

Garlands of holly
 And gay mistletoe,
Friendly warm greetings,
 New-fallen snow.

Carols gaily ringing
 Good news in the air,
Everyone willing
 To help and to share.

Candlelight gleaming,
 The sparkle in eyes,
Little ones watching
 For Santa's surprise.

Loved ones returning
 From far and from near,
Isn't it the most wonderful
 Time of the year?

Kay Hoffman

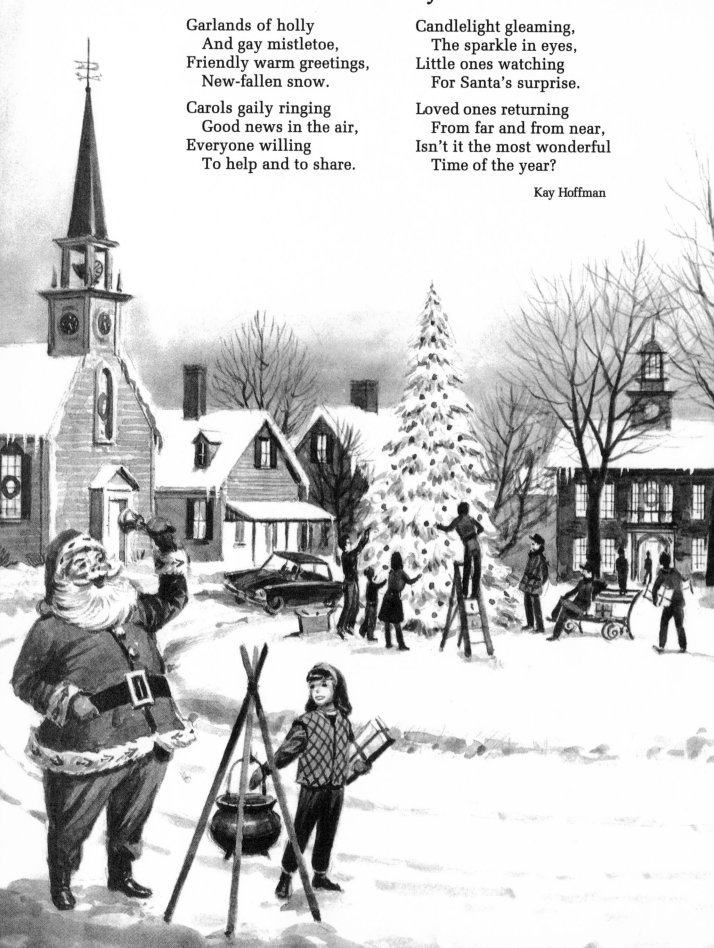

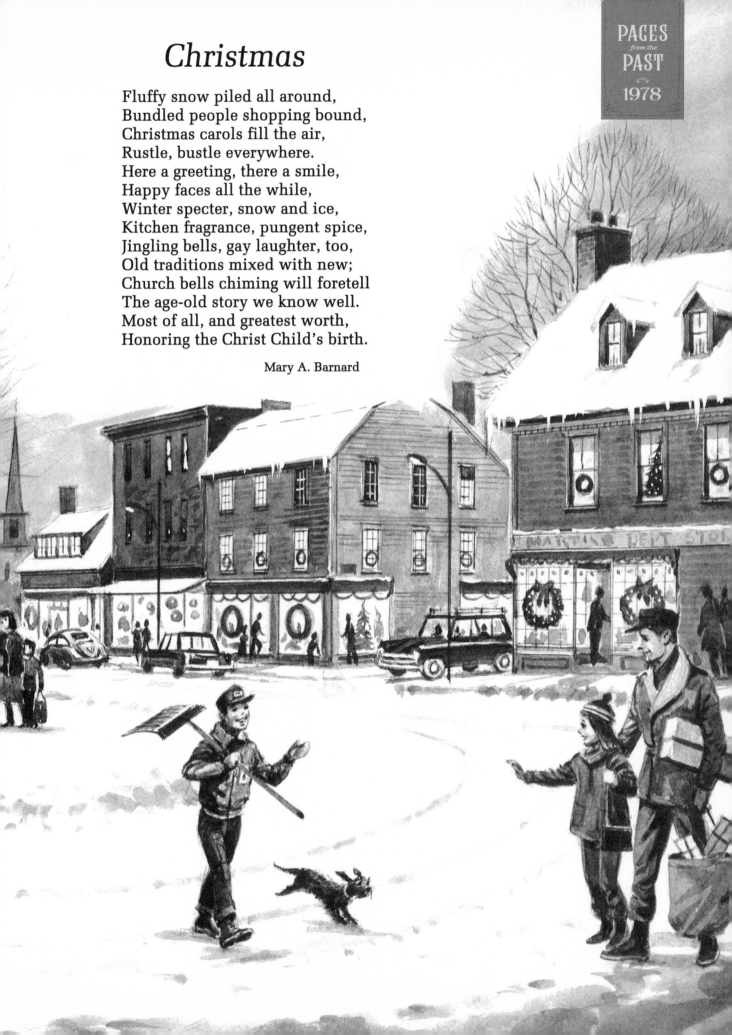

Christmas

Fluffy snow piled all around,
Bundled people shopping bound,
Christmas carols fill the air,
Rustle, bustle everywhere.
Here a greeting, there a smile,
Happy faces all the while,
Winter specter, snow and ice,
Kitchen fragrance, pungent spice,
Jingling bells, gay laughter, too,
Old traditions mixed with new;
Church bells chiming will foretell
The age-old story we know well.
Most of all, and greatest worth,
Honoring the Christ Child's birth.

Mary A. Barnard

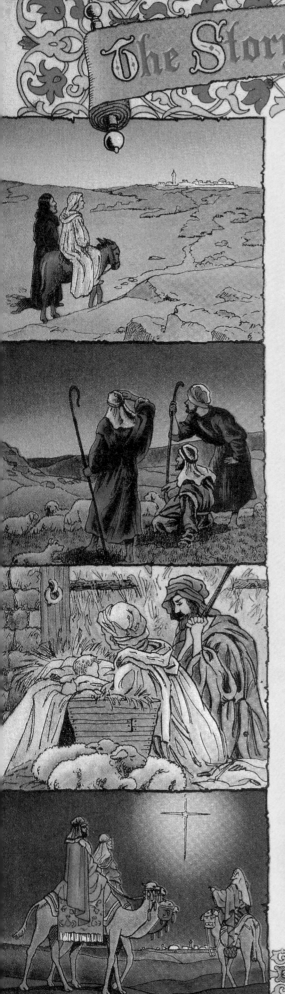

St. Luke Chapter II: IV to XX

AND Joseph also went up from Galilee out of the city of Nazareth into Judea unto the city of David which is called Bethlehem: (because he was of the house and lineage of David). **V**

To be taxed with Mary his espoused wife. **VI**

And so it was that while they were there the days were accomplished that she should be delivered. **VII.** And she brought forth her first-born son and wrapped him in swaddling clothes and laid him in a manger: because there was no room for them in the inn. **VII**

AND there were in the same country shepherds abiding in the field keeping watch over their flocks by night. **IX.** And, lo, the angel of the Lord came up on them and the glory of the Lord shown round about them and they were sore afraid. **X.** And the angel said unto them, Fear not, for behold I bring you good tidings of great joy which shall be to all people. **XI**

For unto you is born this day in the city of David a Savior which is Christ the Lord. **XII**

And this shall be a sign unto you: Ye shall find the babe wrapped in swaddling clothes and lying in a manger. **XIII**

And suddenly there was with the angel a multitude of the heavenly host Praising GOD and saying: **XIV**

Glory to God in the highest and on earth peace, good will toward men.

And it came to pass as the angels were **XV** gone away from them into heaven, the shepherds said one to another Let us now go even unto Bethlehem and see this thing which is come to pass, which the Lord hath made known unto us. **XVI.** And they came with haste and found Mary and Joseph and the baby lying in a manger. **XVII.** And when they had seen it they made known abroad the saying which was told them concerning this child. **XVIII**

And all they that heard it wondered at those things which were told them by the shepherds. **XIX**

BUT Mary kept all these things and pondered them in her heart. **XX.** And the shepherds returned, glorifying and praising GOD for all the things that they had heard and seen.

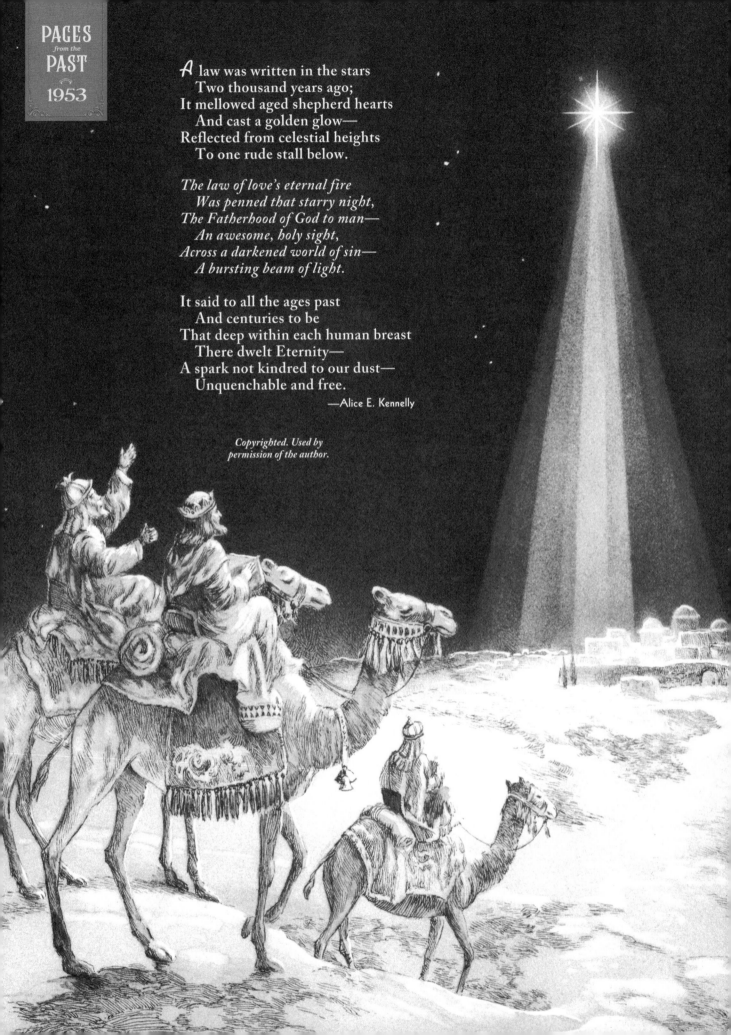

A law was written in the stars
 Two thousand years ago;
It mellowed aged shepherd hearts
 And cast a golden glow—
Reflected from celestial heights
 To one rude stall below.

The law of love's eternal fire
 Was penned that starry night,
The Fatherhood of God to man—
 An awesome, holy sight,
Across a darkened world of sin—
 A bursting beam of light.

It said to all the ages past
 And centuries to be
That deep within each human breast
 There dwelt Eternity—
A spark not kindred to our dust—
 Unquenchable and free.

—Alice E. Kennelly

*Copyrighted. Used by
permission of the author.*

Homeward

Alice Kennelly Roberts

Our day's long search has ended
As evening shadows fell
And brought a triumph to the heart
Which words could never tell;
For though the cold nipped sharply
At fingers, ears, and toes,
We had our tree for Christmas
And now sought night's repose.

The last mile was the longest.
So very tired were we.
Dad pulled the sled; I held the tree,
And, then, home we could see.
Across the snow-swept distance
Our sleepy village lay,
With warmth of friends and loved ones
And happy Christmas Day.

How like our life's long journey,
The trail which Time has made.
The loved ones waiting for us,
The scenes which never fade,
The strength of Someone near us
To lift the heavy load—
These are memories we keep
To cherish on life's road.

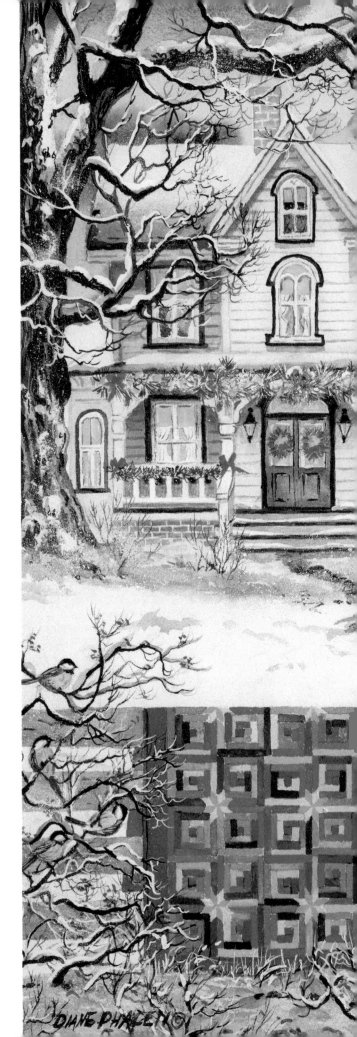

*Lovely Christmas quilts and a friendly snowman
welcome family and friends in Diane Phalen's
painting entitled* COUNTRY CHRISTMAS. *Copyright
© Diane Phalen Watercolors. All rights reserved.*

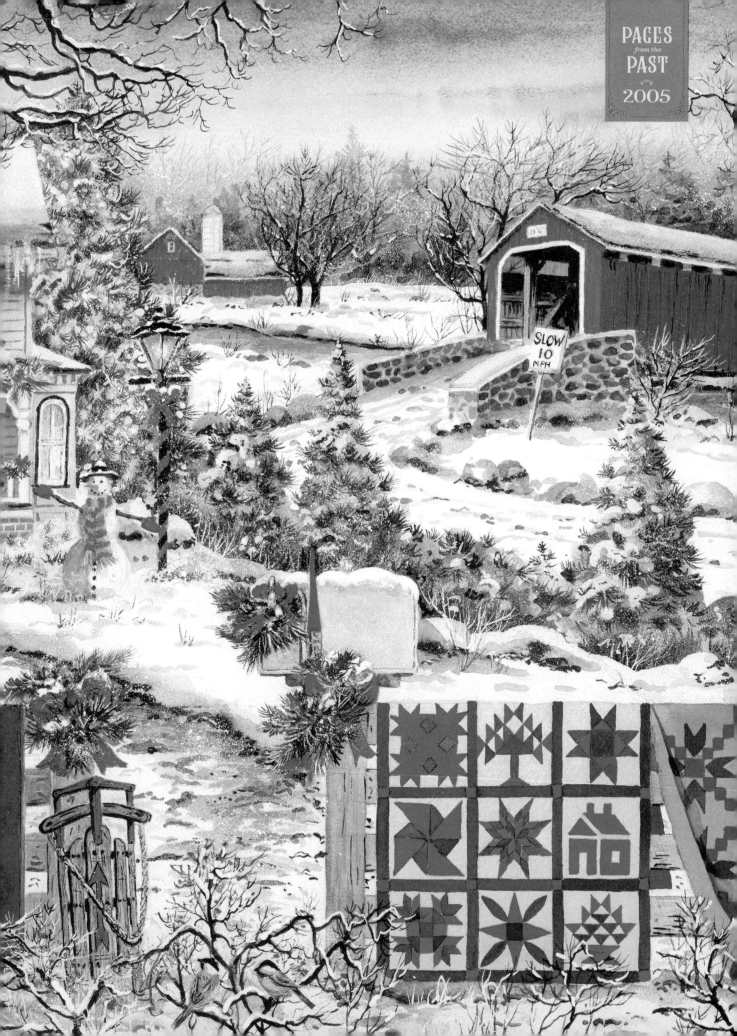

SLOW
10
MPH

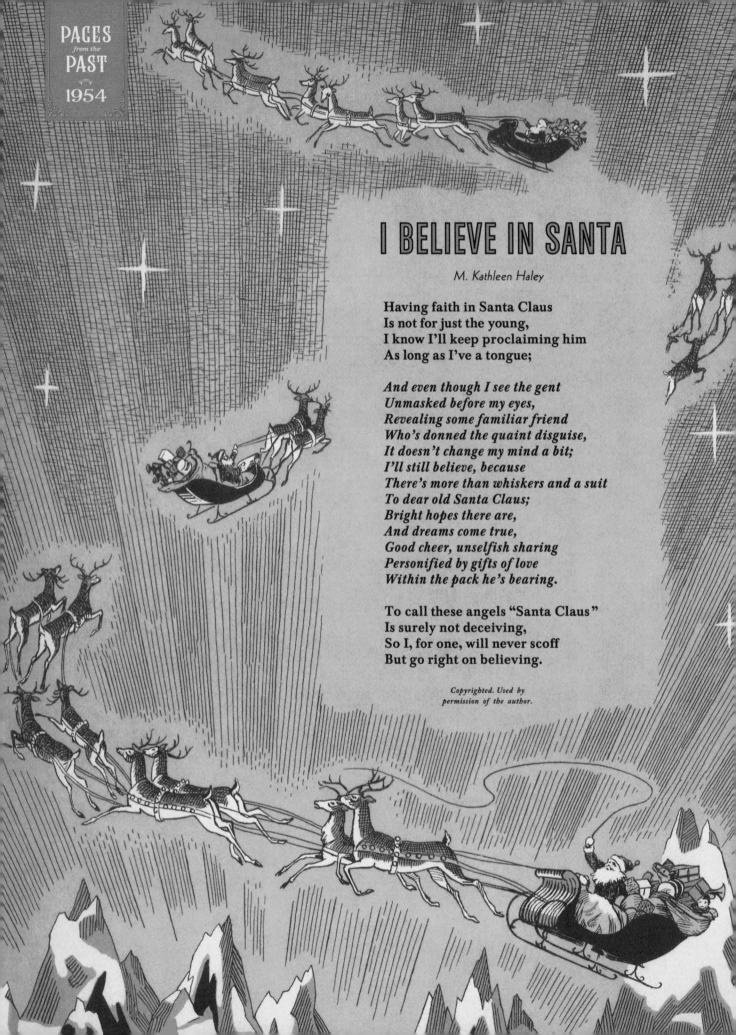

I BELIEVE IN SANTA

M. Kathleen Haley

Having faith in Santa Claus
Is not for just the young,
I know I'll keep proclaiming him
As long as I've a tongue;

*And even though I see the gent
Unmasked before my eyes,
Revealing some familiar friend
Who's donned the quaint disguise,
It doesn't change my mind a bit;
I'll still believe, because
There's more than whiskers and a suit
To dear old Santa Claus;
Bright hopes there are,
And dreams come true,
Good cheer, unselfish sharing
Personified by gifts of love
Within the pack he's bearing.*

To call these angels "Santa Claus"
Is surely not deceiving,
So I, for one, will never scoff
But go right on believing.

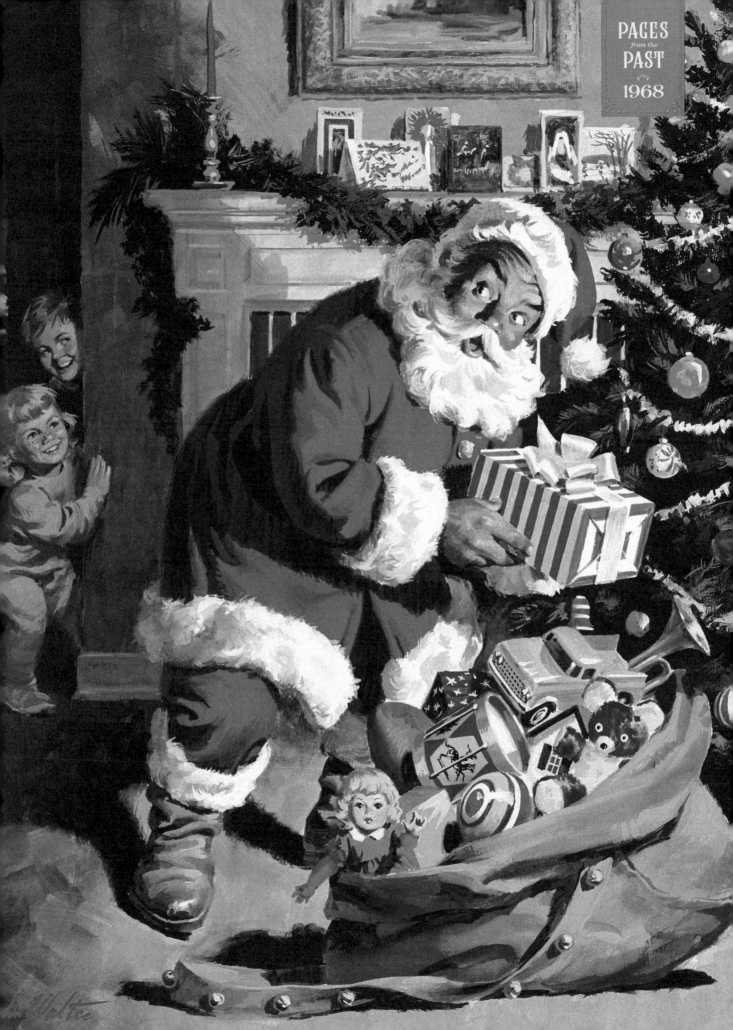

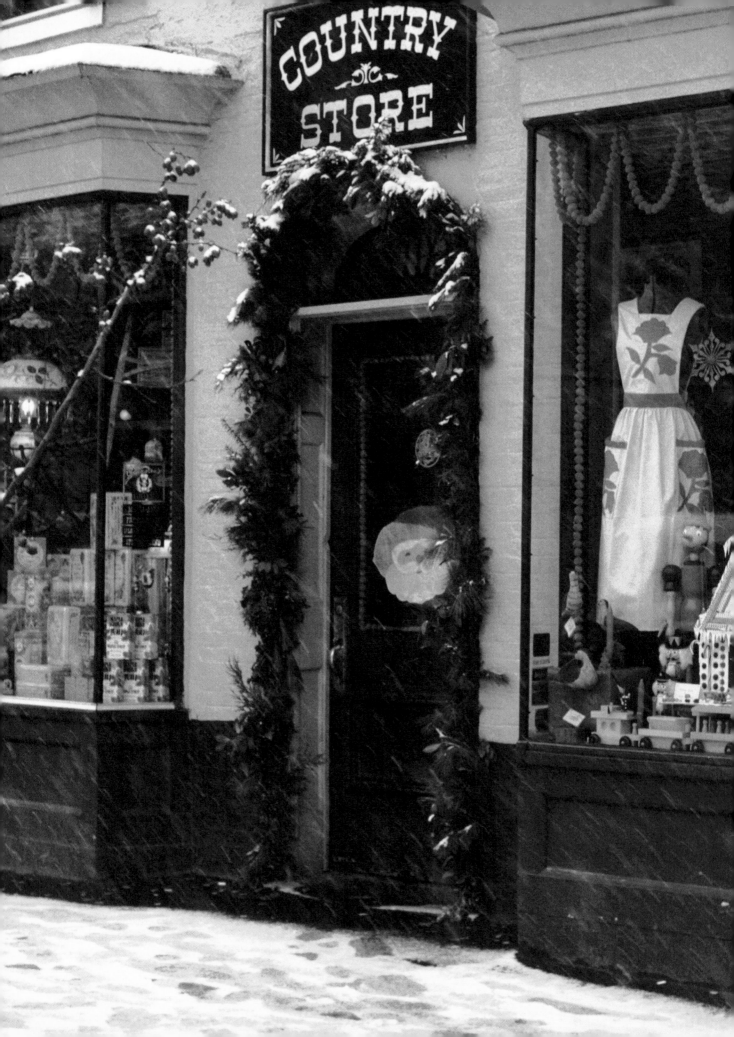

December

Edna Jaques

December takes on festive airs,
Angels walking unawares,
In and out our common doors,
Christmas carols in the store.
Bright-eyed children gaily clad,
Being, oh, so nice to Dad.

Christmas concerts in the church,
Glowing logs of oak and birch
Burning in the polished grate;
Shiny apples on a plate,
Popcorn balls and taffy squares,
Loops of tinsel on the stairs.

Mother busy all day long,
On her lips a happy song
As she beats and stirs and bakes
Fat old-fashioned Christmas cakes,
Raisin cookies, doughnuts, ham,
Golden tarts with berry jam.

December is a joyful time,
Christmas bells that gaily chime,
Rosy cheeks and eyes aglow,
Starry skies and fields of snow—
'Tis no wonder that she wears
Happy looks and festive airs.

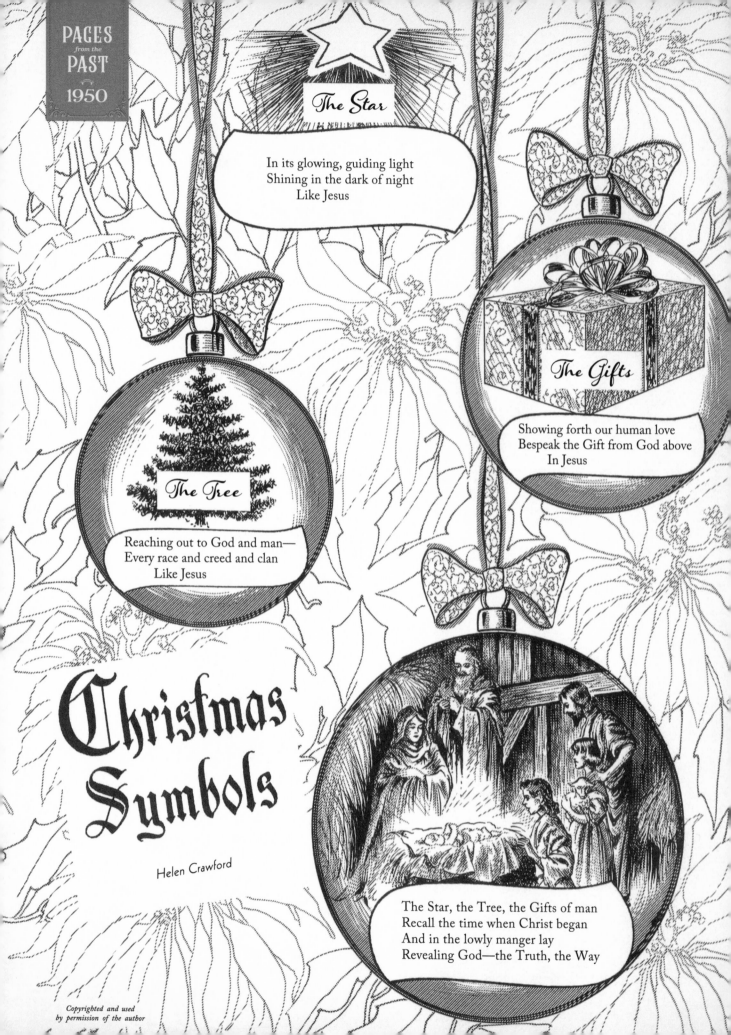

The Star

In its glowing, guiding light
Shining in the dark of night
Like Jesus

The Gifts

Showing forth our human love
Bespeak the Gift from God above
In Jesus

The Tree

Reaching out to God and man—
Every race and creed and clan
Like Jesus

Christmas Symbols

Helen Crawford

The Star, the Tree, the Gifts of man
Recall the time when Christ began
And in the lowly manger lay
Revealing God—the Truth, the Way

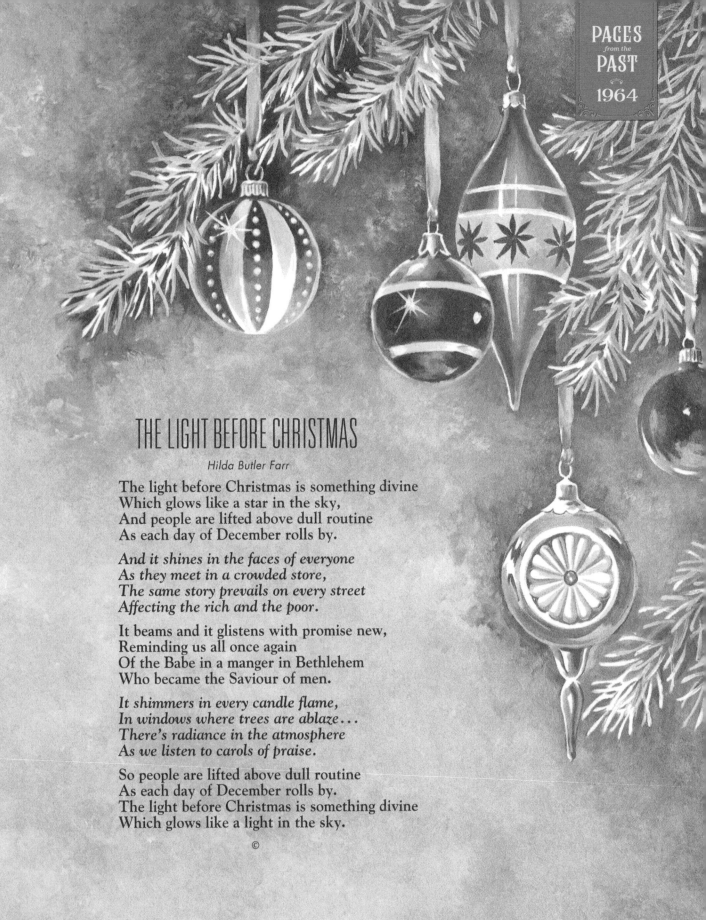

THE LIGHT BEFORE CHRISTMAS

Hilda Butler Farr

The light before Christmas is something divine
Which glows like a star in the sky,
And people are lifted above dull routine
As each day of December rolls by.

*And it shines in the faces of everyone
As they meet in a crowded store,
The same story prevails on every street
Affecting the rich and the poor.*

It beams and it glistens with promise new,
Reminding us all once again
Of the Babe in a manger in Bethlehem
Who became the Saviour of men.

*It shimmers in every candle flame,
In windows where trees are ablaze…
There's radiance in the atmosphere
As we listen to carols of praise.*

So people are lifted above dull routine
As each day of December rolls by.
The light before Christmas is something divine
Which glows like a light in the sky.

©

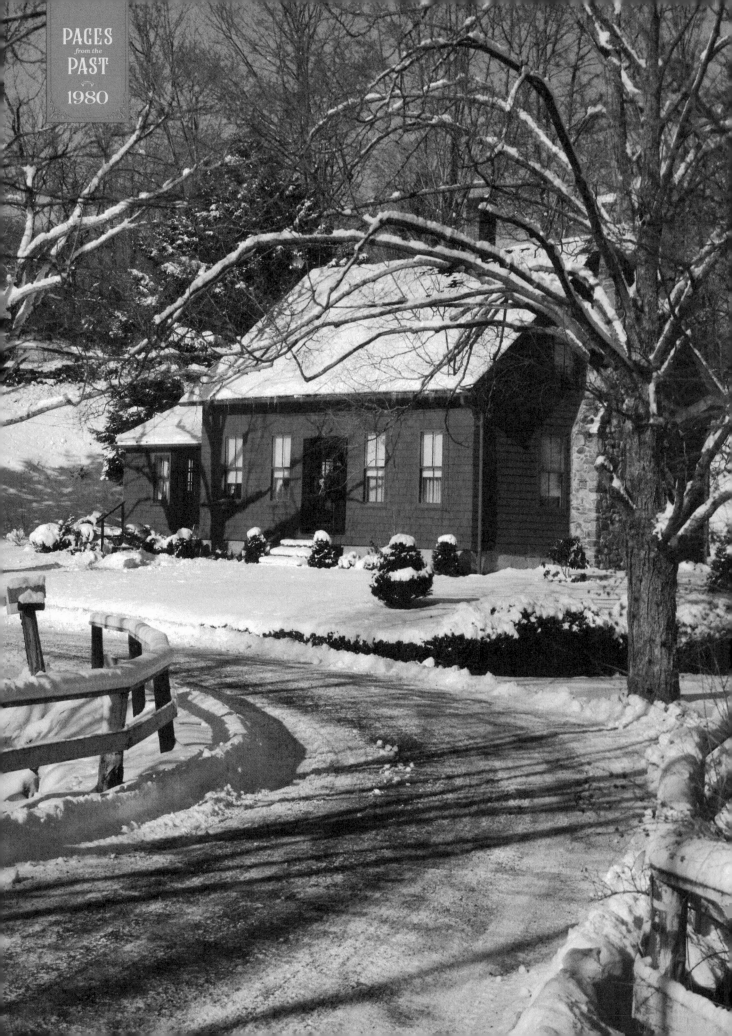

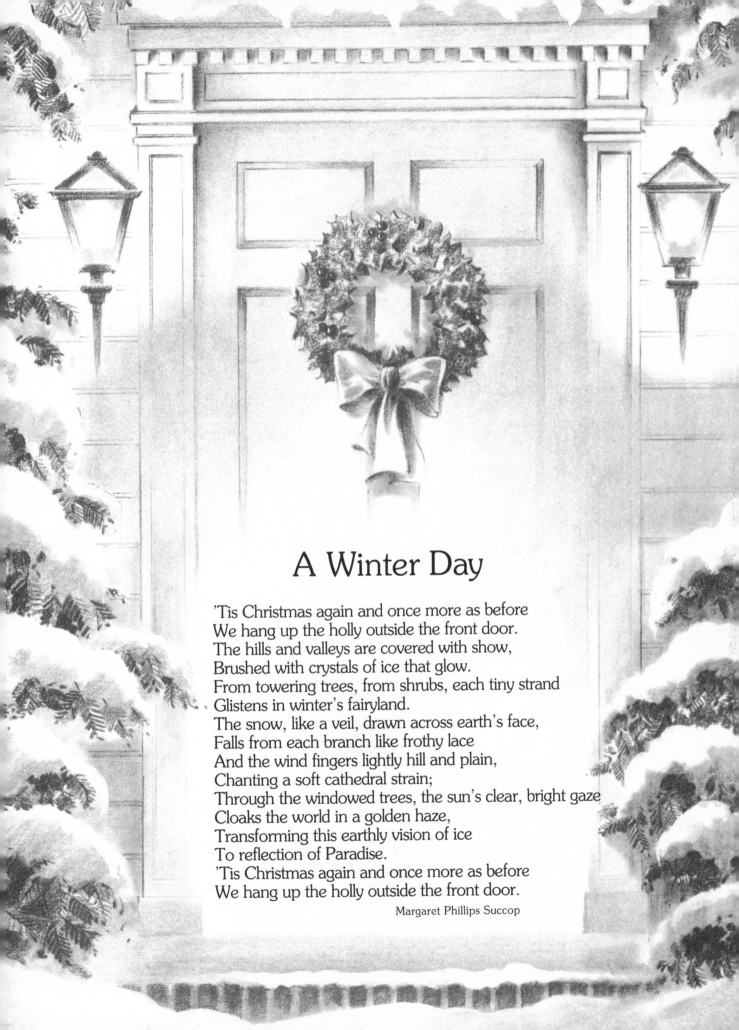

A Winter Day

'Tis Christmas again and once more as before
We hang up the holly outside the front door.
The hills and valleys are covered with show,
Brushed with crystals of ice that glow.
From towering trees, from shrubs, each tiny strand
Glistens in winter's fairyland.
The snow, like a veil, drawn across earth's face,
Falls from each branch like frothy lace
And the wind fingers lightly hill and plain,
Chanting a soft cathedral strain;
Through the windowed trees, the sun's clear, bright gaze
Cloaks the world in a golden haze,
Transforming this earthly vision of ice
To reflection of Paradise.
'Tis Christmas again and once more as before
We hang up the holly outside the front door.

Margaret Phillips Succop

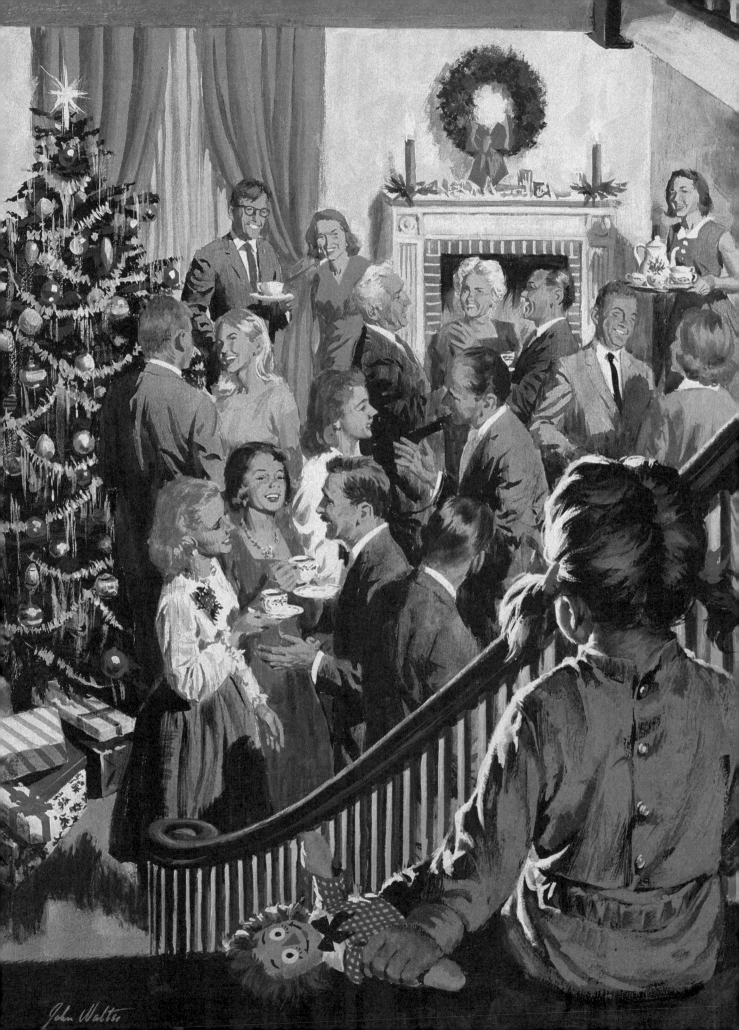

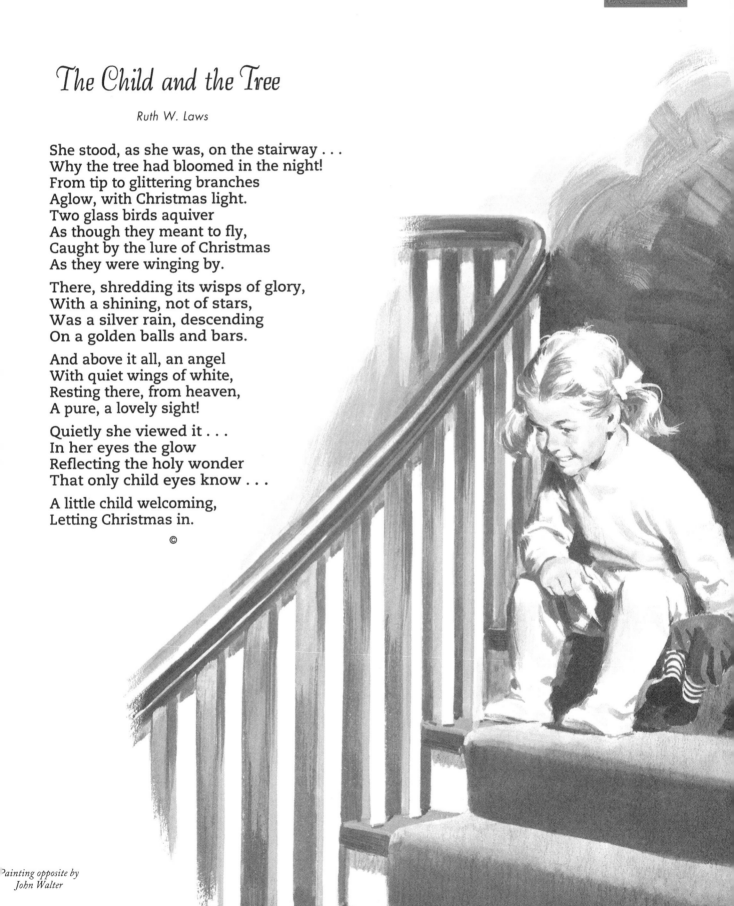

The Child and the Tree

Ruth W. Laws

She stood, as she was, on the stairway . . .
Why the tree had bloomed in the night!
From tip to glittering branches
Aglow, with Christmas light.
Two glass birds aquiver
As though they meant to fly,
Caught by the lure of Christmas
As they were winging by.

There, shredding its wisps of glory,
With a shining, not of stars,
Was a silver rain, descending
On a golden balls and bars.

And above it all, an angel
With quiet wings of white,
Resting there, from heaven,
A pure, a lovely sight!

Quietly she viewed it . . .
In her eyes the glow
Reflecting the holy wonder
That only child eyes know . . .

A little child welcoming,
Letting Christmas in.

©

*Painting opposite by
John Walter*

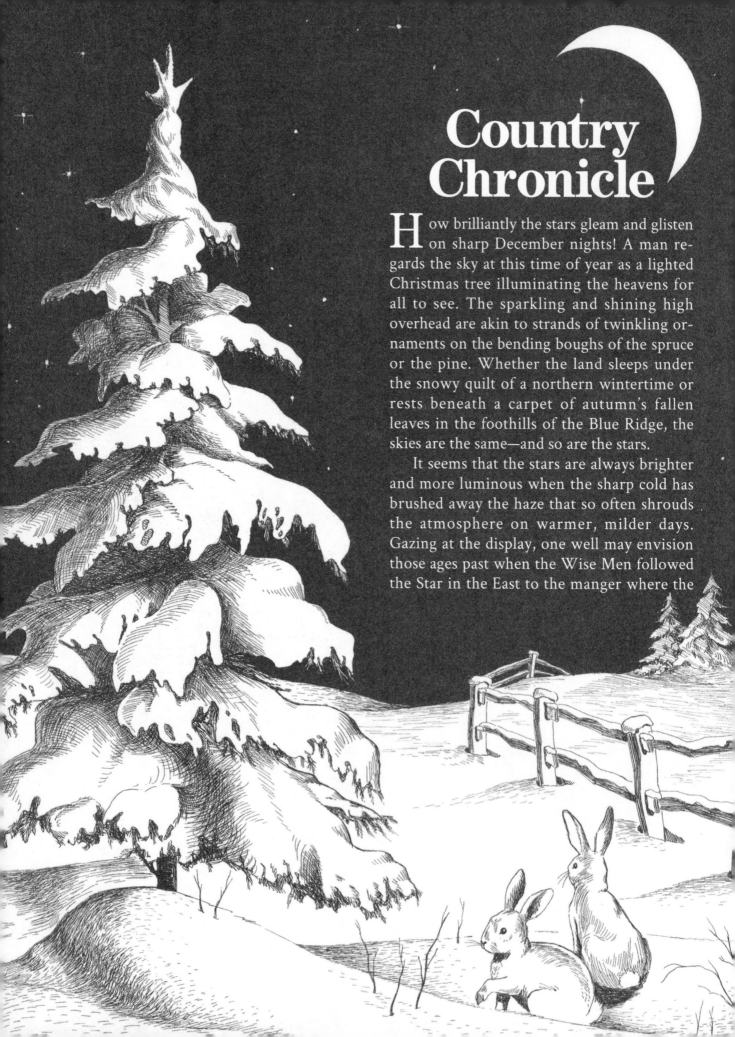

Country Chronicle

How brilliantly the stars gleam and glisten on sharp December nights! A man regards the sky at this time of year as a lighted Christmas tree illuminating the heavens for all to see. The sparkling and shining high overhead are akin to strands of twinkling ornaments on the bending boughs of the spruce or the pine. Whether the land sleeps under the snowy quilt of a northern wintertime or rests beneath a carpet of autumn's fallen leaves in the foothills of the Blue Ridge, the skies are the same—and so are the stars.

It seems that the stars are always brighter and more luminous when the sharp cold has brushed away the haze that so often shrouds the atmosphere on warmer, milder days. Gazing at the display, one well may envision those ages past when the Wise Men followed the Star in the East to the manger where the

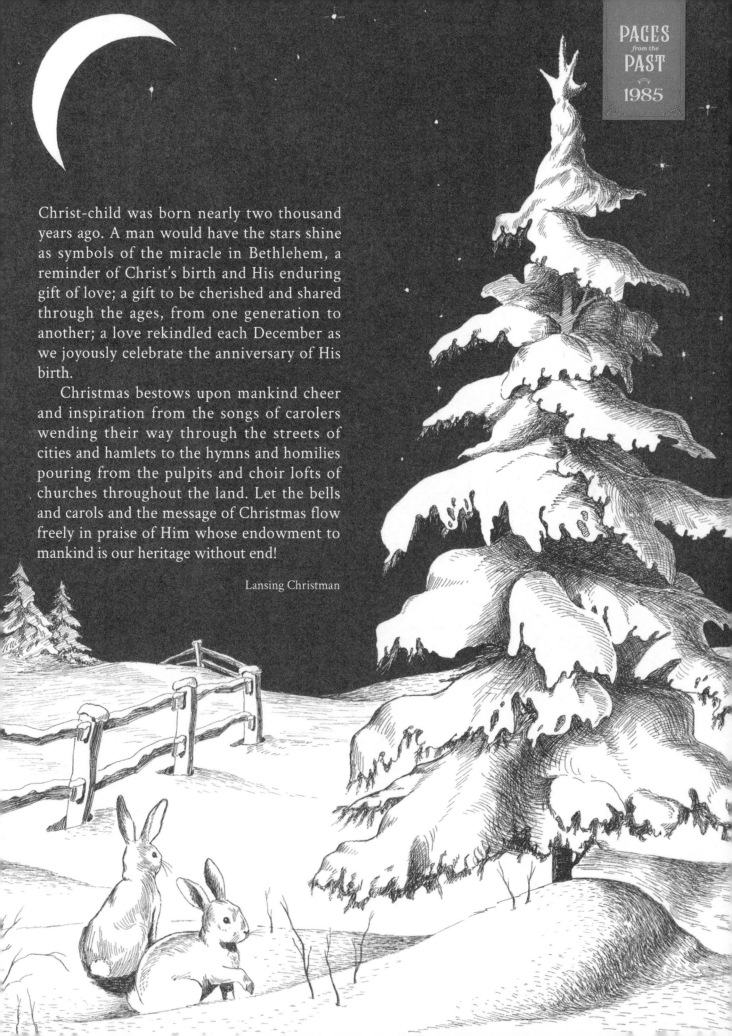

Christ-child was born nearly two thousand years ago. A man would have the stars shine as symbols of the miracle in Bethlehem, a reminder of Christ's birth and His enduring gift of love; a gift to be cherished and shared through the ages, from one generation to another; a love rekindled each December as we joyously celebrate the anniversary of His birth.

Christmas bestows upon mankind cheer and inspiration from the songs of carolers wending their way through the streets of cities and hamlets to the hymns and homilies pouring from the pulpits and choir lofts of churches throughout the land. Let the bells and carols and the message of Christmas flow freely in praise of Him whose endowment to mankind is our heritage without end!

Lansing Christman

Let's Think Of Christmas

Lois Anne Williams

It is the time of Christmas,
So full of hope and peace;
Let's think of things that mean so much,
Of joys that never cease.

I think of Mary and Joseph
Resting in the stable bare
And of the blessed miracle
That we know happened there.

I think about the shepherds
Who heard the angels sing;
They were afraid till the angels said,
"Fear not, good news we bring."

I think about the wise men
Who had journeyed from afar
Bearing gifts to Jesus;
They were guided by the star.

I think of Christmas candles
As they shed their glow so bright,
Reminding that the light of God
Came down to earth that night.

I think of all the carols
Which are lovely, sweet, and gay . . .
They tell the blessed story
Of the Christ Child born that day.

I think of Christmas greetings
Bringing words from far and near;
Their messages are peace and joy
And a wish for the New Year.

At this happy Christmas season
We remember Christ our King,
And though we have no costly gifts
Ourselves to him we bring.

©

Engrossment by
Paul Mann

For unto you is born this day in the city of David a SAVIOUR, which is Christ the LORD

PAUL MANN

Luke 2:11.

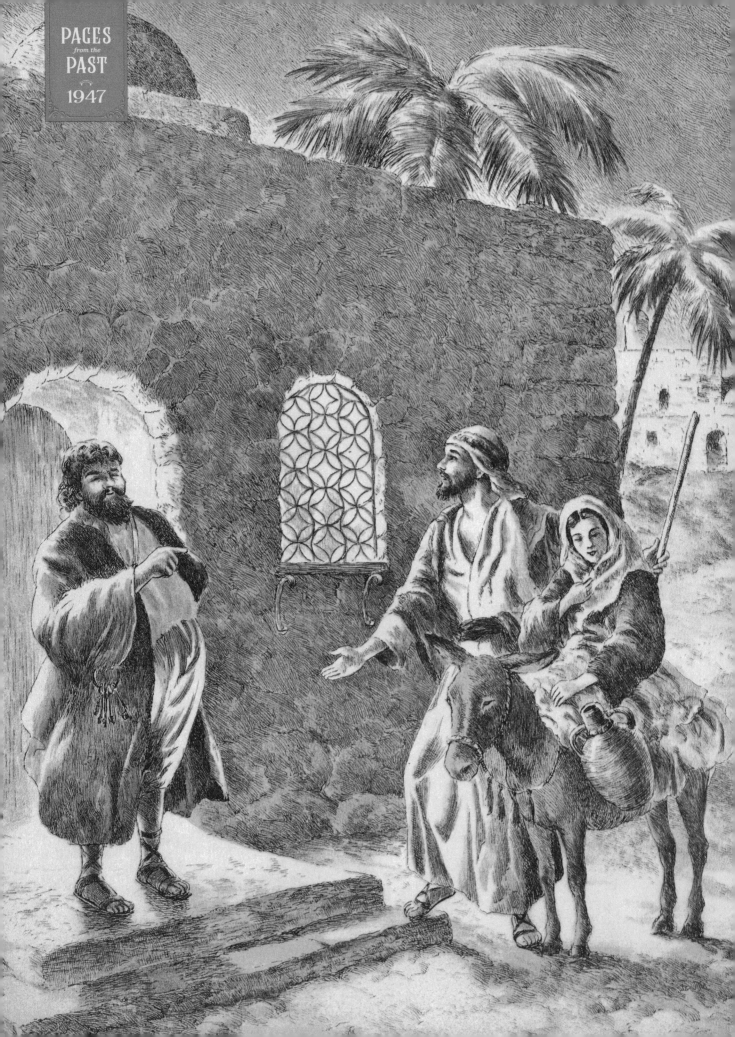

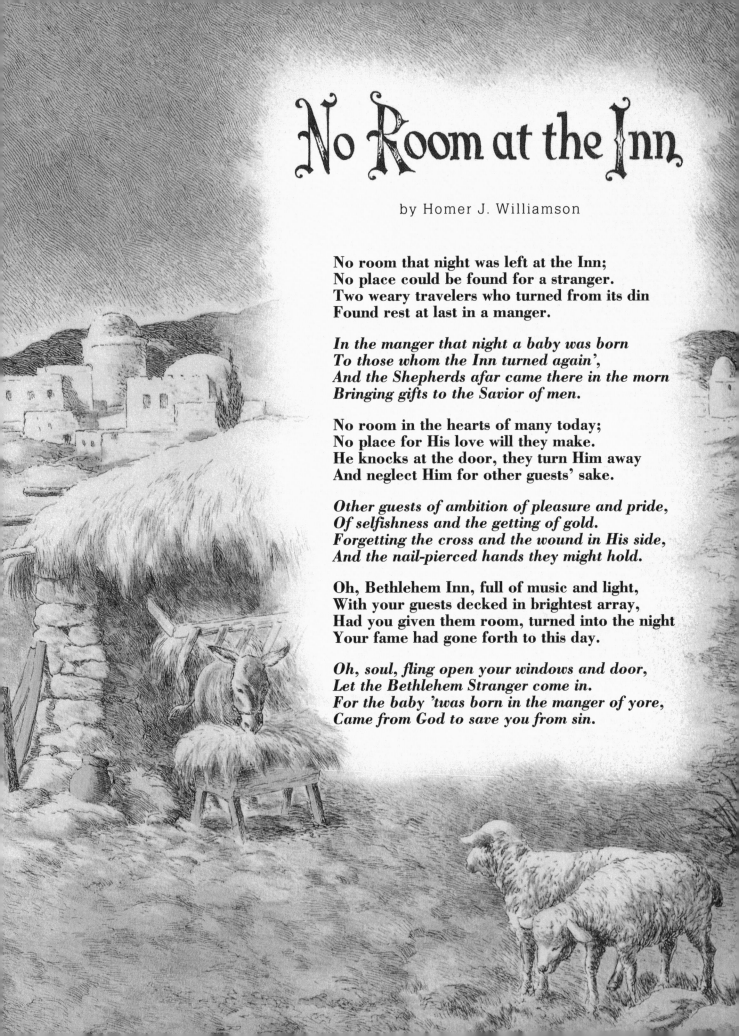

No Room at the Inn

by Homer J. Williamson

No room that night was left at the Inn;
No place could be found for a stranger.
Two weary travelers who turned from its din
Found rest at last in a manger.

*In the manger that night a baby was born
To those whom the Inn turned again',
And the Shepherds afar came there in the morn
Bringing gifts to the Savior of men.*

No room in the hearts of many today;
No place for His love will they make.
He knocks at the door, they turn Him away
And neglect Him for other guests' sake.

*Other guests of ambition of pleasure and pride,
Of selfishness and the getting of gold.
Forgetting the cross and the wound in His side,
And the nail-pierced hands they might hold.*

Oh, Bethlehem Inn, full of music and light,
With your guests decked in brightest array,
Had you given them room, turned into the night
Your fame had gone forth to this day.

*Oh, soul, fling open your windows and door,
Let the Bethlehem Stranger come in.
For the baby 'twas born in the manger of yore,
Came from God to save you from sin.*

The Contributors of *ideals*

Ideals has always benefited from the contributions of talented individuals—from poets and essayists to photographers and painters. Though the list of those whose work has graced the pages of *Ideals* throughout the years is too long to fit here, a few names merit special mention.

Poets as famous as Robert Frost and Emily Dickinson have been featured alongside reader favorites Edna Jaques, Grace Noll Crowell, and Edgar A. Guest. Moving, thoughtful prose has been penned by Gladys Taber, Hal Borland, Lansing Christman, and Pamela Kennedy, just to name a few. Lesser-known poets and essayists also found a regular home in *Ideals*, submitting their work to our editorial offices over seven decades.

Talented photographers such as Dennis Frates, Fred Sieb, and Jessie Walker helped bring the text selections to life. Masterpieces of European and American art have been represented in the pages of *Ideals*, as have the works of accomplished artists such as Jay Killian, Frances and Richard Hook, and John Slobodnick. These visual artists and so many more have all contributed to the rich tradition and timeless appeal of *Ideals*.

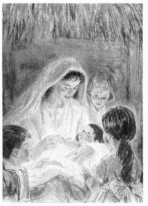

Clockwise from top left: paintings by Ray App, Frances Hook, John Walter, and Donald Mills

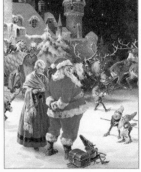

Paintings by George Hinke

Perhaps the most iconic art in *Ideals* is that of George Hinke. Born in Berlin in 1883, he trained under master painters in Germany. Hinke emigrated to America and eventually to Milwaukee in 1923. He began working for *Ideals* in its first year of publication and painted for the company until his death in 1958. His subjects for *Ideals* included beautiful floral work, landscapes, nostalgic scenes, and religious paintings—like the painting, opposite, of the Wise Men approaching the infant Jesus. He is most well-known, though, for his depictions of Santa Claus, which influenced the American conception of Saint Nick. Old-world details like cuckoo clocks and his mischievous elves add to the charm of each piece. The inside covers of this edition are from two of his most famous Santa Claus paintings, one of which was featured on the cover of the 1946 issue of *Ideals*.

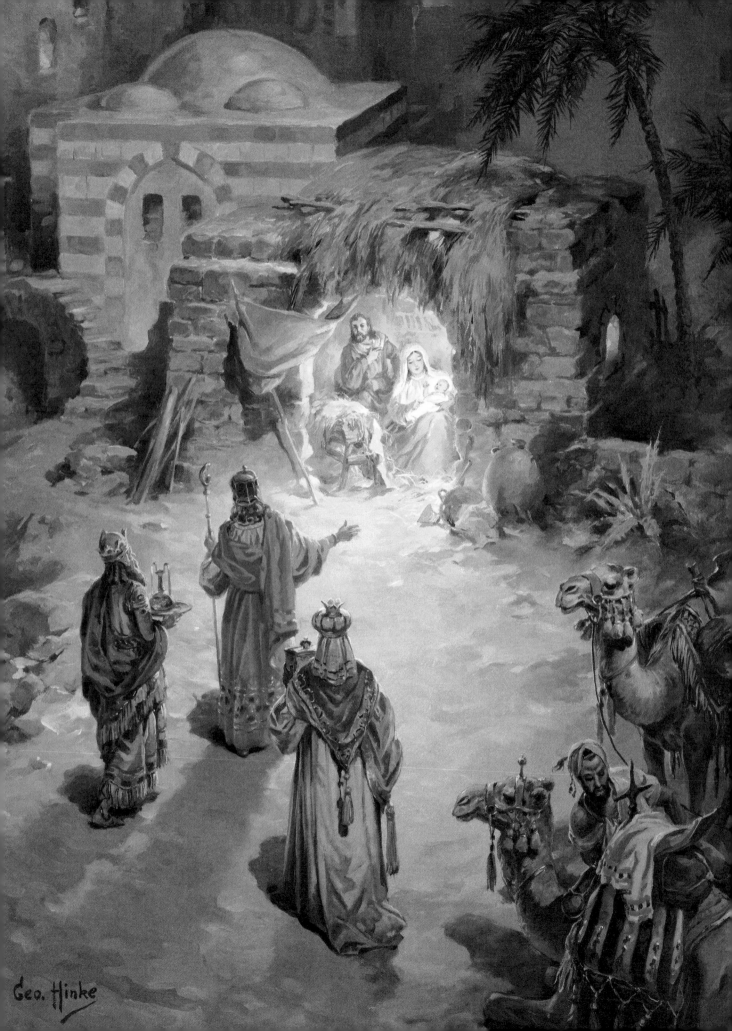

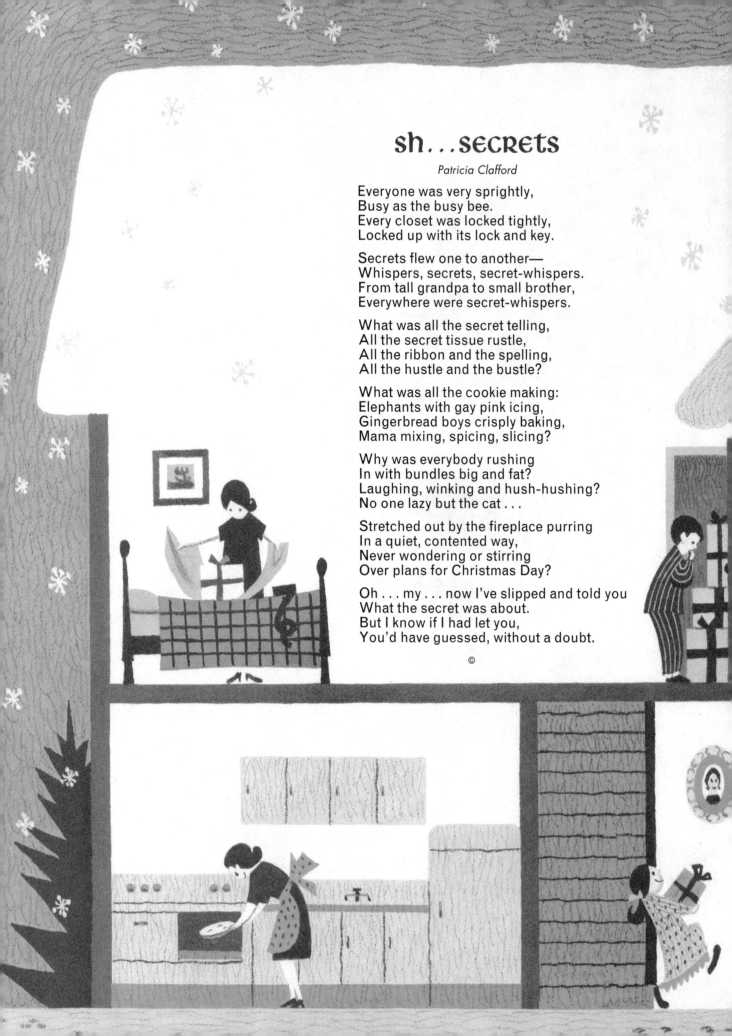

sh...secrets

Patricia Clafford

Everyone was very sprightly,
Busy as the busy bee.
Every closet was locked tightly,
Locked up with its lock and key.

Secrets flew one to another—
Whispers, secrets, secret-whispers.
From tall grandpa to small brother,
Everywhere were secret-whispers.

What was all the secret telling,
All the secret tissue rustle,
All the ribbon and the spelling,
All the hustle and the bustle?

What was all the cookie making:
Elephants with gay pink icing,
Gingerbread boys crisply baking,
Mama mixing, spicing, slicing?

Why was everybody rushing
In with bundles big and fat?
Laughing, winking and hush-hushing?
No one lazy but the cat . . .

Stretched out by the fireplace purring
In a quiet, contented way,
Never wondering or stirring
Over plans for Christmas Day?

Oh . . . my . . . now I've slipped and told you
What the secret was about.
But I know if I had let you,
You'd have guessed, without a doubt.

©

my house is clean for christmas

Mary E. Rathfon

My house is clean for Christmas now;
That is, except one nook,
Where, through a solemn vow I made,
I promised not to look.

I heard my little girl slip in
From school the other day
And softly climb the creaky stairs
To hide a gift away

That she had made all by herself
For no one else but me,
And then beneath the bureau placed . . .
Sure of security.

So, when she heard me say I'd clean,
She made me promise not
To move the bureau in her room,
But clean around the spot.

So, though my house is Christmas cleaned,
One place is filled with dust.
But what's a little thing like that
Compared to my child's trust?

©

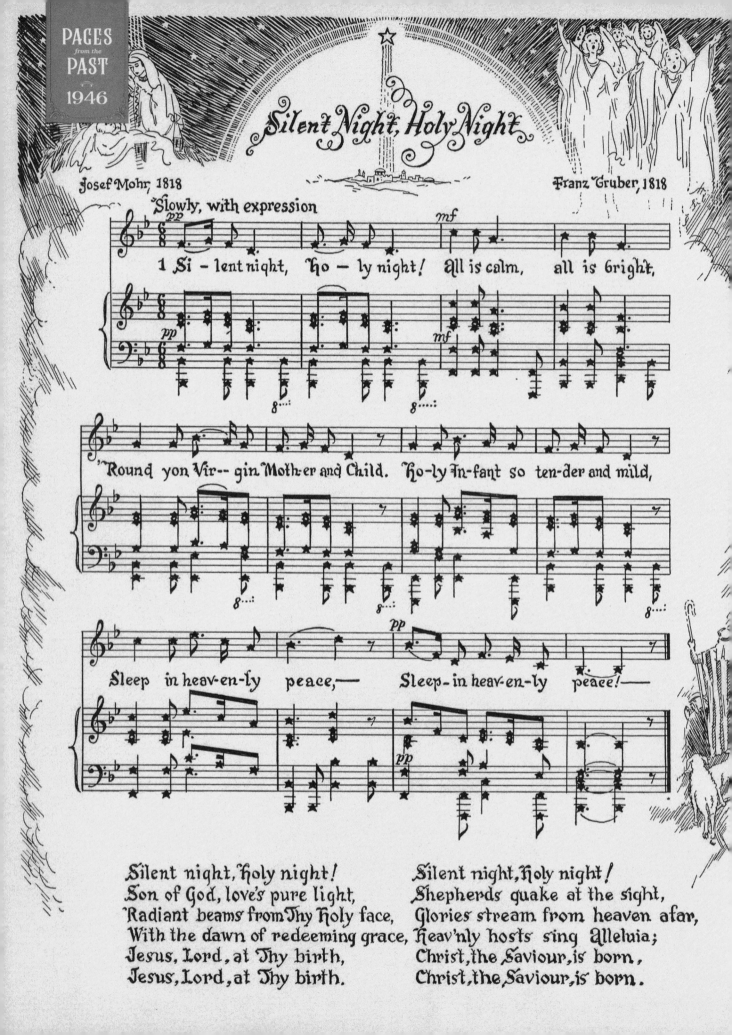

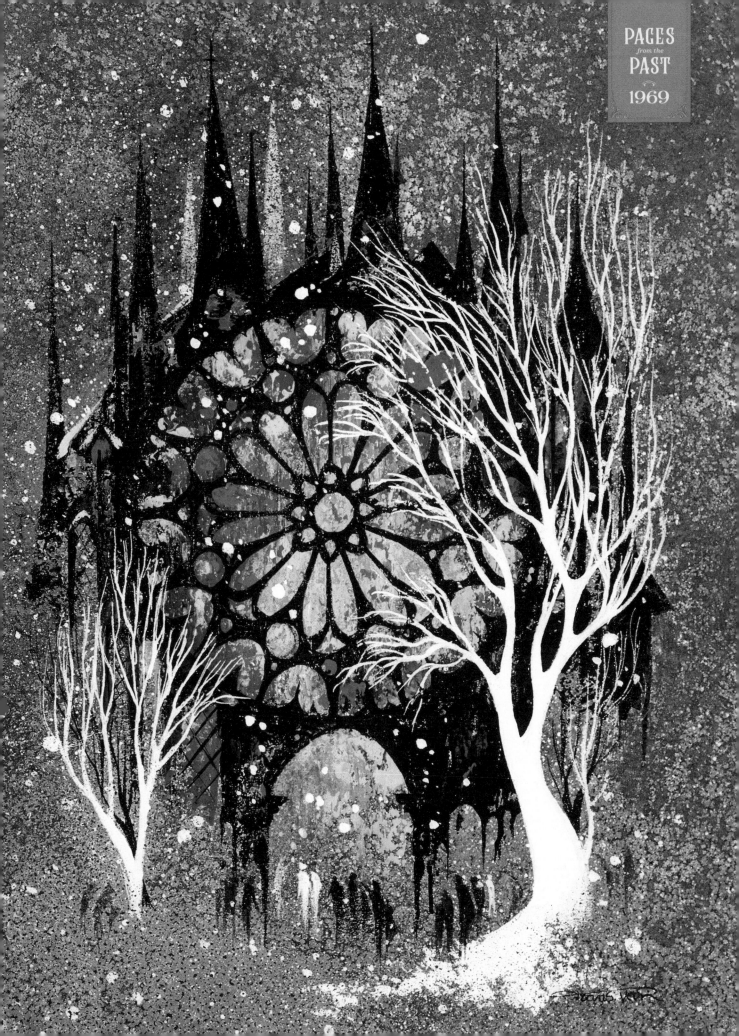

The Joys of Christmas
Rebecca Barlow Jordan

Happy hearts, tuned together;
special moments shared in love;
making memories, festive fun—
all the things worth dreaming of.

Favorite friends; love and laughter;
times reflecting on the past;
thankful hearts, joined as one,
make the joys of Christmas last.

ISBN: 978-1-5460-1454-6

Worthy
Hachette Book Group
1290 Avenue of the Americas
New York, NY 10104

Printed and bound in the U.S.A.

Publisher, Peggy Schaefer
Editor, Melinda Rathjen
Designer, Marisa Jackson
Associate Editor, Kristi Breeden
Copy Editor, Amanda Sauer

Cover: *Waiting to Cross* by Bonnie White. Image © Bonnie White
Inside front cover: Painting by George Hinke. Image © Ideals Publications
Inside back cover: Painting by George Hinke. Image © Ideals Publications

Sheet Music for "The Friendly Beasts" by Dick Torrans, Melode, Inc. Additional art credits: art for "Bits & Pieces" by Lisa Reed, "Family Recipes" and spot art for page 1 by Kathy Rusynyk.

Join the community of *Ideals* readers on Facebook at: www.facebook.com/IdealsMagazine

Readers are invited to submit original poetry and prose for possible use in future publications. Please send no more than four typed submissions to: Hachette Book Group, Attn: *Ideals* Submissions, 6100 Tower Circle, Suite 210, Franklin, Tennessee 37067. Editors cannot guarantee your material will be used, but we will contact you if we do wish to publish.

ACKNOWLEDGMENTS

GRAHAM, BILLY. Adapted from "Three Symbols of Christmas." *Decision*, December 1960. Copyright © 1958 Billy Graham Evangelistic Association, used by permission. All rights Reserved. MCCALL'S MAGAZINE. "Christmas Thoughts for All the Year," 1959. Used without objection and with permission from the Meredith Corporation. OUR THANKS to the following authors or their heirs for permission granted or for material submitted for publication: June Master Bacher, Mary A. Barnard, John C. Bonser, Nora M. Bozeman, Johnielu Barber Bradford, Anne Kennedy Brady, Clara Brummert, Lansing Christman, Patricia Clafford, Helen Crawford, Joan Donaldson, Marion Doyle, Hilda Butler Farr, J. Harold Gwynne, M. Kathleen Haley, Vera Ramsdell Hardman, Kay Hoffman, Reginald Holmes, Edna Jaques, Mildred L. Jarrell, Deana Johnson, Jewell Johnson, Rebecca Barlow Jordan, Pamela Kennedy, Minnie Klemme, Ruth W. Laws, Pamela Love, E'lane Carlisle Murray, Doris A. Paul, Dale Purvis, Mary E. Rathfon, Alice Kennelly Roberts, Garnett Ann Schultz, Betty Wallace Scott, Eileen Spinelli, Margaret Phillips Succop, Susan Sundwall, Homer J. Williamson, Lois Anne Williams, Elisabeth Weaver Winstead, Mary Stoner Wine.

Scripture quotations, unless otherwise indicated, are taken from the King James Version (KJV). Scripture quotation marked NKJV is from the New King James Version®. Copyright © 1982 by Thomas Nelson. Used by permission. All rights reserved.

Every effort has been made to establish ownership and use of each selection in this book. If contacted, the publisher will be pleased to rectify any inadvertent errors or omissions in subsequent editions.